HOUSES OF WORSHIP

HOUSES OF WORSHIP

MARK SCHACTER

FIFTH
HOUSE

Published in Canada by Fifth House Ltd., 195 Allstate Parkway, Markham, Ontario L3R 4T8

Published in the United States by Fifth House Ltd., 311 Washington Street, Brighton, Massachusetts 02135

All inquiries should be addressed to Fifth House Ltd., 195 Allstate Parkway, Markham, Ontario L3R 4T8.

www.fifthhousepublishers.ca

10 9 8 7 6 5 4 3 2 1

Library and Archives Canada Cataloguing in Publication

ISBN 9781927083178

Cataloguing data available from Library and Archives Canada

Publisher Cataloging-in-Publication Data (U.S.)

ISBN 9781927083178

Data available on file

Fifth House Ltd. acknowledges with thanks the Canada Council for the Arts, and the Ontario Arts Council for their

support of our publishing program. We acknowledge the financial support of the Government of Canada

through the Canada Book Fund (CBF) for our publishing activities.

Design by Kerry Designs

Printed in Canada by Friesens

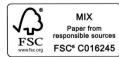

Contents

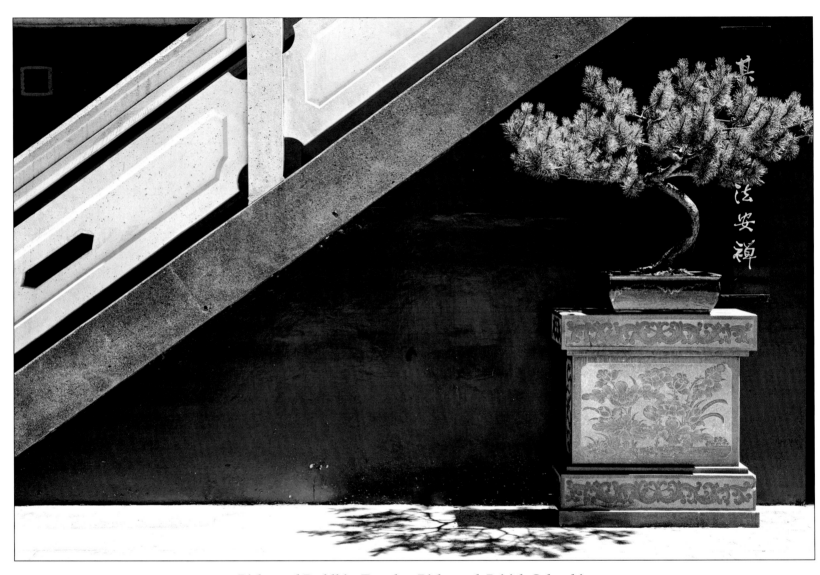

Richmond Buddhist Temple – Richmond, British Columbia

Introduction

THE ORIGINS OF THIS book are mysterious, even to me.

I was born into Jewish heritage. My mother was an atheist. But my father, though not devout, was a devotee of religious tradition and practice. The rituals of Judaism gave him comfort and pleasure—he went to the synagogue often. As a schoolboy he had a rigorous Jewish education, remarkable given that he lived in Thunder Bay, Ontario—a small city with a tiny (albeit, in the mid-1900s, vigorous) Jewish community.

My father projected onto me his love of Jewish ritual and expected me to share it. I attended the synagogue, went to religious classes three times a week, learned to read and speak Hebrew and read from the Torah, and celebrated my bar mitzvah in Israel.

Much of that time now seems like a distant, different life. I have long since abandoned the pretense of practicing Judaism or any other faith. I do not pray. I do not believe in God.

So why have I produced this book? Is it even possible to provide an explanation?

In searching for a rationale I find a clue in a story my father told me when I was a boy. He recounted it more than once, each time as if it was the first. It was a story from the 1930s when he was in his teens. Times were grim. My father's mother had recently died. His family was poor and struggled mightily, along with so many others through the Great Depression. From across the Atlantic loomed the rising spectre of Nazism. Jews in Thunder Bay, though far removed from the wellspring of Hitler's anti-Semitic genocidal mania, had their own reasons to feel ill at ease. They were an isolated pocket of a few hundred souls—far removed from the cosmopolitan acceptance (or so they imagined it) of Toronto or Winnipeg—who could not quite shed the uncomfortable mantle of "being different."

It was against this dark and menacing background that my father's little story was set. He sat in the synagogue on an autumn evening with his father and brothers. (His stepmother and sisters would have sat separately from the men, in the orthodox tradition.) It was the eve of Yom Kippur—the Day of Atonement—the most solemn day in the Jewish calendar. The entire community (or close to it) would have gathered in the simple clapboard building for the Kol Nidre service, itself one of the most dramatic and emotional elements of the entire Jewish liturgy. And at some point during the prayers a rock crashed through one of the building's windows.

It was an isolated incident, perhaps a calculated expression of hatred or maybe just a prank. But under the circumstances—with the political situation in Europe and the global economic depression aggravating the community's endemic sense of insecurity—the overtones were ominous. There was still a chill in my father's voice when he told me the story

more than thirty years later.

A rock thrown through the window of a home violates private, personal space. But when the rock comes through the window of a house of worship it violates a community. The building itself, more than whatever group of individuals may be inside at the moment of the attack, is the target because of what it represents: a particular community's free and open practice of its faith. Beyond that (and perhaps even more relevant to the rock-thrower), the building is also an expression of attachment: a visible, tangible, durable statement that says, *We have a place here; we belong here.*

The rock through the window is a powerfully inarticulate denial of all that. It is the equivalent of saying, *You shall not gather here to practice your faith; you have no place here; you are an outsider; you don't belong.* Hence the chill in my father's voice all those many years later.

I spent my own childhood in that same small city where the rock was thrown. Though times had changed since my father's early years, old habits of racial and religious prejudice lingered. While it would be ludicrous to suggest I was persecuted or seriously ill-treated because of my religious background, I did learn to take for granted a constant, casual, low-grade kind of anti-Semitism—teasing and taunting and other unkind acts that grade-school children are expert at performing.

The experience thickened my skin, made me more resilient than I might otherwise have been, and gave me a certain detachment from my surroundings. As well, it forced me to develop a quick wit and sense of humour (because I wasn't much of a fist fighter, and so

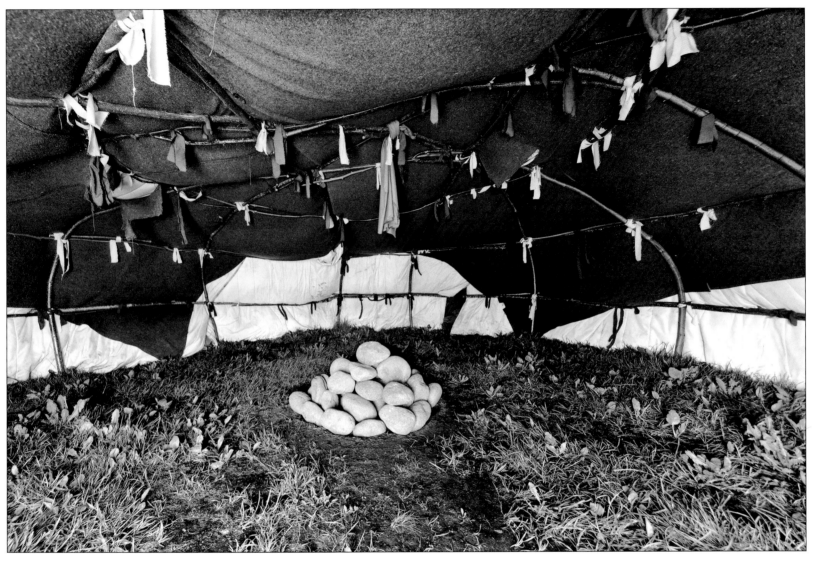

Sweat Lodge, Mission Correctional Institution – Mission, British Columbia

The sweat lodge is part of a spiritual ceremony performed by First Nations cultures throughout Canada and the United States. This involves an elaborate process of building a small, covered structure and then heating stones in an outdoor fire until they are glowing. The stones are brought into the lodge to heat it up and create a steaminess similar to that of a sauna. Upon entering the sweat lodge, participants engage in meditation and sharing of words, prayers, songs, and storytelling, all of which is intended to bring about spiritual renewal and purification of the body, mind, and soul.

needed a different kind of defence mechanism). But there are scars too, the most obvious being the queasy feeling of not-belonging that still invades my dreams on many nights, disturbing my sleep.

And so I circle back to my interest in producing images of houses of worship. It comes down to this: for better or for worse I am attuned to seeing the world from an outsider's perspective. Indeed, I find it fascinating to be in the position of an outsider looking in on a world where I don't belong, a world whose beliefs and rituals I do not fully understand. Where religious faith is concerned I am the ultimate outsider. I'm drawn to the mystery of it—what greater mystery to an unbeliever than faith?

Faith is as invisible as it is mysterious, but a photographer can still point a camera at tangible signs of its existence. This reminds me of a technique from the equally mysterious world of particle physics, where physicists use a liquid-filled "bubble chamber" to investigate unimaginably small subatomic particles. Too minuscule to be seen directly, their presence is announced by a delicate track of bubbles, visible to the eye, that forms in the wake of each particle as it travels through the liquid. By studying photographs of the bubble tracks, scientists learn about the unseen particles. In exploring the mystery of faith my "bubble tracks" are the buildings that shelter the faithful. The man-made structures are the visible accompaniment of the ethereal phenomenon. The resulting photographs in this volume comprise a study—in bricks, clapboard, shingles, concrete, and steel—of evidence of religious faith.

Among other things, the photographs will perhaps invite you to consider some paradoxes inherent in the notion of a "house of worship"— questions examined in a recently

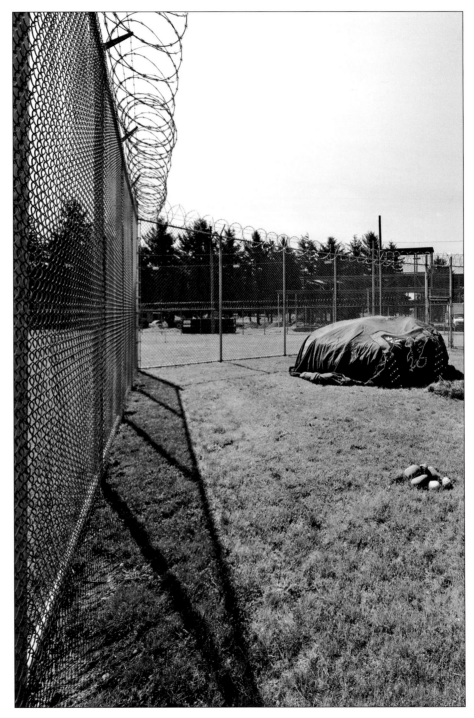

Sweat Lodge, Fraser Valley Correctional Institution – Abbotsford, British Columbia

published collection of essays by architects and scholars[1]—as well as in interviews with religious leaders that I undertook for this project. Houses of worship are inherently material, of-this-world things, yet they are devoted to that which is non-material and other-worldly. How then does one make sense of those mosques, churches, synagogues, temples, and gurdwaras that far surpass—through decoration, grandeur, and opulent building materials—the basic function of sheltering the faithful? Do such structures glorify the very materiality that faith would have us negate? Or is the material splendour merely a vehicle for transporting worshippers to a spiritual place where material things are of no importance?

Similarly, while architecture is founded on precision and rationality, faith underscores the limits of human rationality; indeed it operates in a realm beyond reason. To design and build a house of worship requires measurement and logic; but the purpose for which it is built defies both measurement and logic.

Architects and scholars have also pondered the question of what makes a space "sacred."[2] As the photographs in this book demonstrate, some houses of worship are simple, unadorned, and even unattractive. At the same time, they are assumed to be sacred places. So is it the building itself that gives the space a sacred quality, or is sacredness derived from the devotions of worshippers, present and past, who occupy or have occupied the space?

One thing is clear: a house of worship in its own right—regardless of what it looks like, the faith it represents, or the individuals who enter it—is a potent symbol. Sometimes

1. *Constructing the Ineffable: Contemporary Sacred Architecture*, Karla Cavarra Britton, ed., New Haven: Yale School of Architecture, 2010.
2. *Idem.*

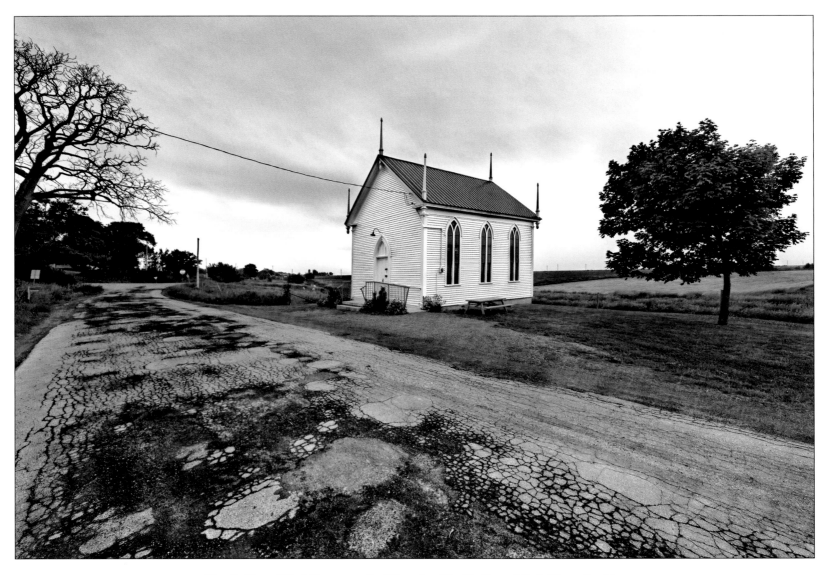

North Grand Pré Community Church – North Grand Pré, Nova Scotia

this symbolic power invites hateful, destructive acts, as in the story told by my father. Intolerance likes easy targets and houses of worship, which by their nature must be easy to access, fit the bill. During a ten-day period in various places around the United States in August 2012 while I was gathering material for this book, seven mosques were defaced and a Sikh gurdwara was attacked by a gunman who killed six people inside. At least two of the houses of worship I photographed—mosques in Gatineau, Quebec, and Charlottetown, Prince Edward Island—had been defaced or threatened in the recent past. In other places, my presence outside a house of worship raised fears. Though standing on public property I was told to put down my camera outside synagogues in Vancouver, British Columbia, and Toronto, Ontario. In Winnipeg, Manitoba, I accidentally left my camera bag just outside the grounds of a Hindu temple. The caretaker seized the bag and searched it for weapons and explosives. In all three cases concern about possible attacks was cited.

But it's equally possible that the symbolism of houses of worship will have the opposite effect on people, inspiring tolerance and respect instead of inciting ill will. You don't have to be religious, much less adhere to a particular faith, to recognize that houses of worship are visible signs of universal human needs for certainty, a sense of purpose and a connection to something that outlasts an earthly lifetime. Even an ardent atheist can look at a house of worship and see the signs of an invisible human longing that is common to us all.

This idea of a universal symbolism embedded in houses of worship—a symbolism as relevant to unbelievers as to the faithful—was not well-formed in my mind at the beginning of the project, but it steadily revealed itself and became clearer to me as the work

progressed. Much later, though, when I was almost finished with the photography, a second overarching idea presented itself to me as a result of a chance encounter. This was the idea that I might be "photographing history."

In June 2013, I was taking photographs inside the Cathedral of the Immaculate Conception in Saint John, New Brunswick. I was struck by the silence, grandeur, and serenity of the place. And then a parishioner struck up a conversation, directing my attention upward to water stains on the ceiling and walls. "The roof leaks," he said, and then he pointed out an area on the floor where the line of pews was broken by a section of temporary seating. "We had to take out those benches because the wood was rotted by water dripping from the ceiling."

"The Archdiocese has to raise $10 million to cover the cost of repairs. That's unlikely given the size of the local Catholic population, and the relatively small proportion that practices the faith," he added.

The obvious implication was that the need for major repairs, combined with the shortage of funds to undertake them, was casting serious doubt over the long-term survival of the building.

"You are photographing history," he said to me. I hadn't conceived of this project in those terms, but he was probably right.

In Canada we are in an era of declining involvement in organized religion. The 2011 Canadian census found that almost one out of four Canadians describes himself or herself

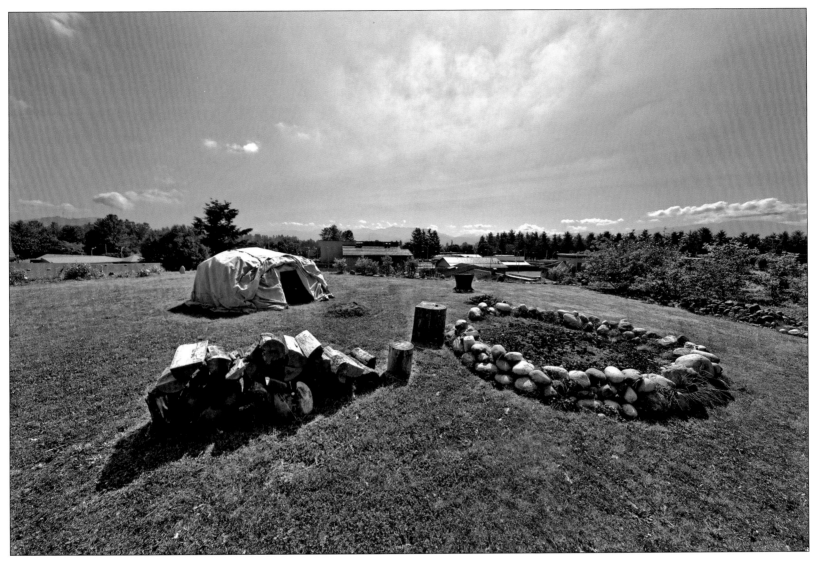

Sweat Lodge, Fraser Valley Correctional Institution – Abbotsford, British Columbia

as having "no religion," a proportion nearly double the 13 percent of Canadians who put themselves in that category in 1991. In many communities the stock of visible religious infrastructure—houses of worship—is a vestige of an earlier time when many more people believed in God (or said they did) and participated regularly in communal observation of their faith in houses of worship.

And so these photographs may conjure up two distinct and opposing themes. On the one hand you have the eternal and the universal, represented by a fundamental human desire to believe in something larger than life, to "have faith," and on the other hand is the transient and the changeable, represented by buildings whose endurance and usefulness will always be limited and uncertain.

Mark Schacter, Ottawa, June 2013

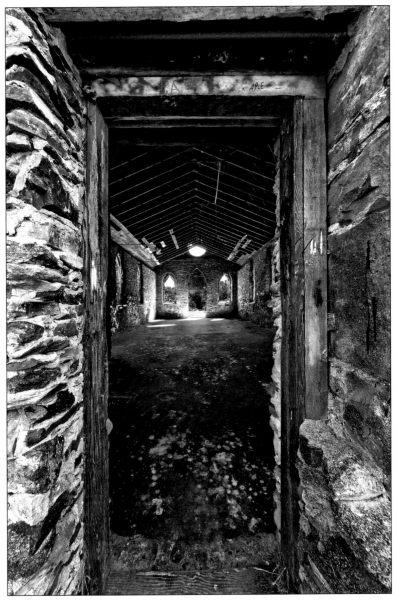

Butter Church – Duncan, British Columbia

In 1870, Father Peter Rondeault, a Catholic missionary from Quebec, built this stone structure with funds raised by selling butter from his dairy herd. But because of uncertain title over the land on which the church stood, the building was used for only ten years before being abandoned and repeatedly vandalized. Local Cowichan Indians regarded it as haunted. In 1980 it was rebuilt as a cultural centre but was again abandoned and so resumed its lonely watch as a ghostly sentinel on Comiaken Hill. Its original doors and stained-glass windows were installed in St. Paul's Church on Saltspring Island, British Columbia.

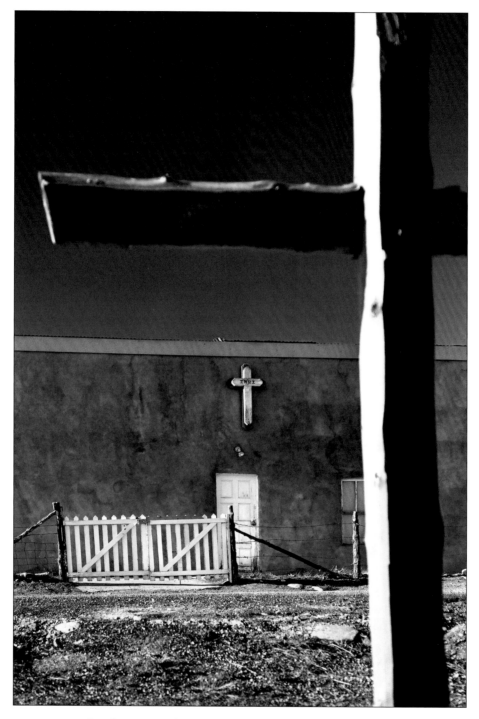

Penitente Brothers Morada – Truchas, New Mexico

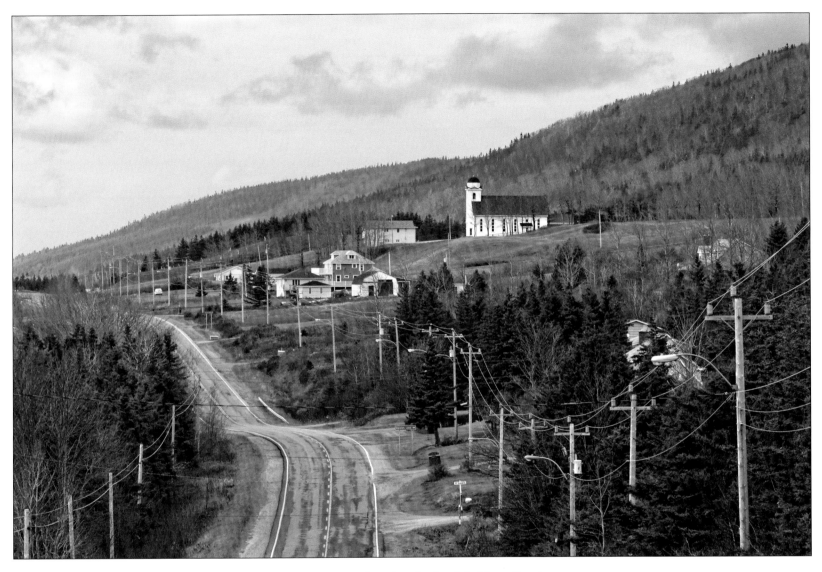

Stella Maris Church – Creignish, Nova Scotia

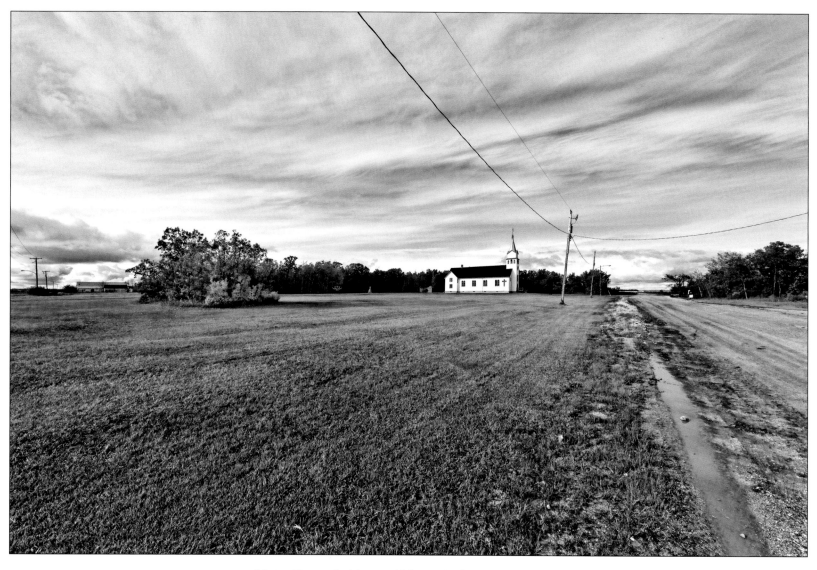

Notre Dame de Toutes Aides – Rorketon, Manitoba

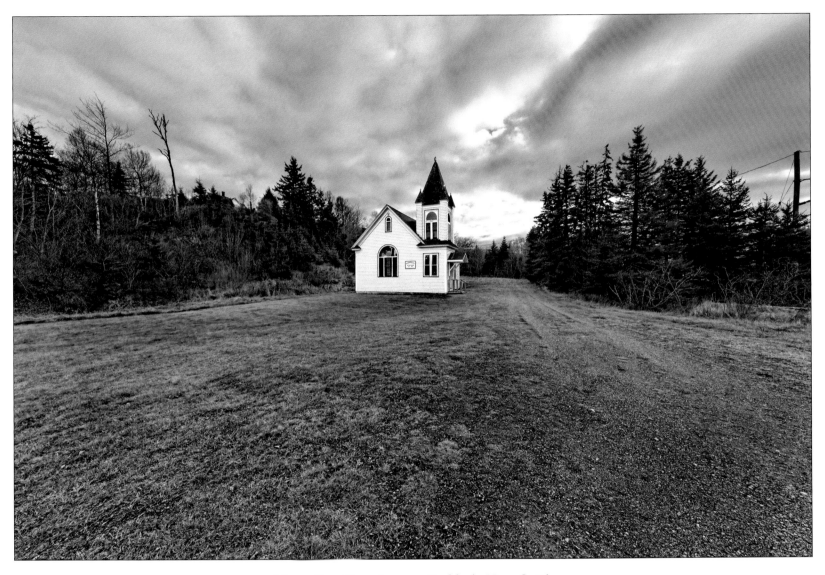

Glenvalley Church – near Baddeck, Nova Scotia

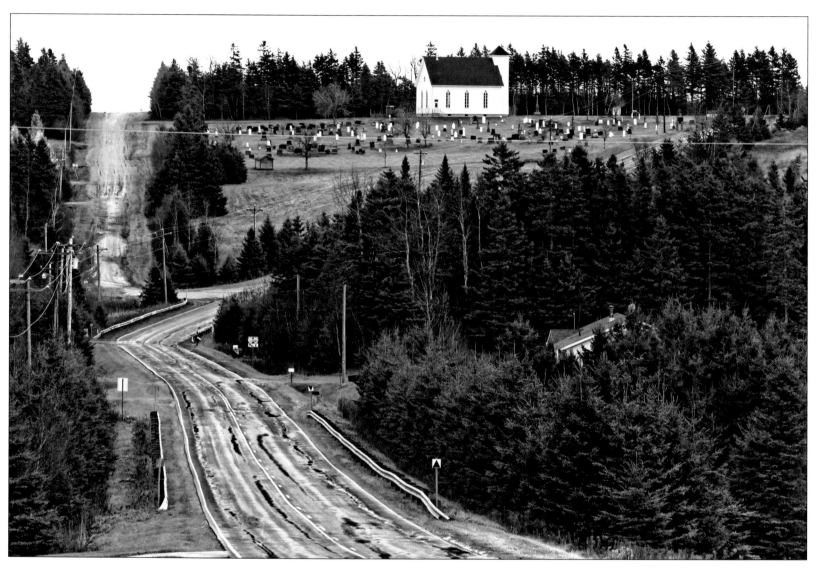

Hartsville Presbyterian Church – Hartsville, Prince Edward Island

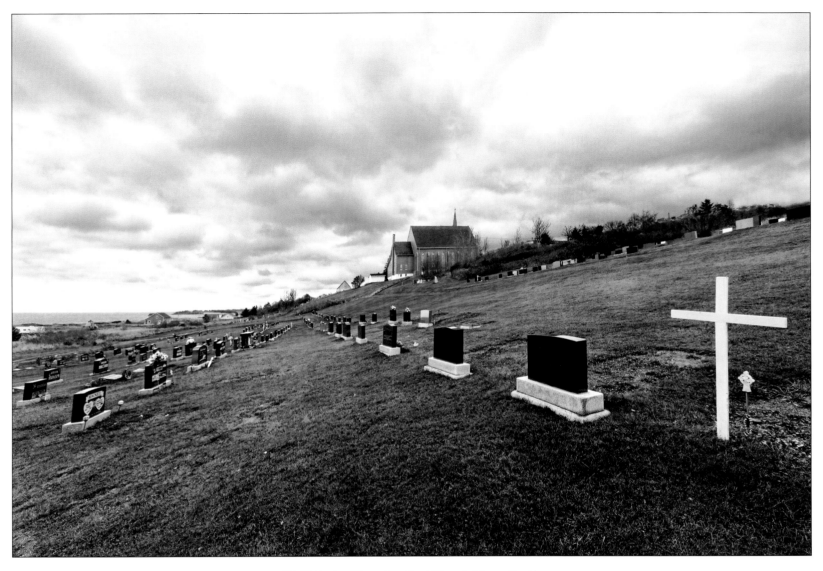

St. Peter's Church – Port Hood, Nova Scotia

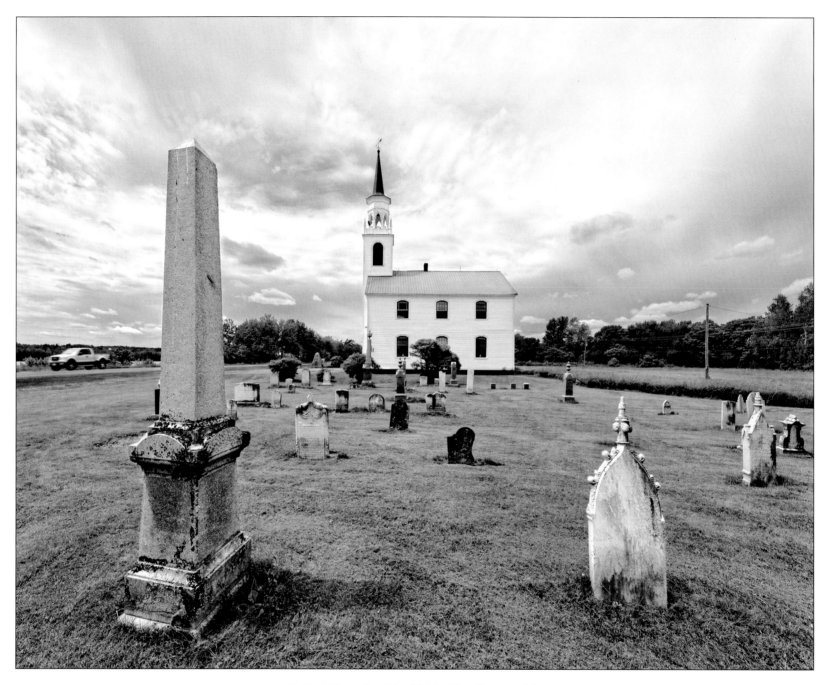

United Church – Sheffield, New Brunswick

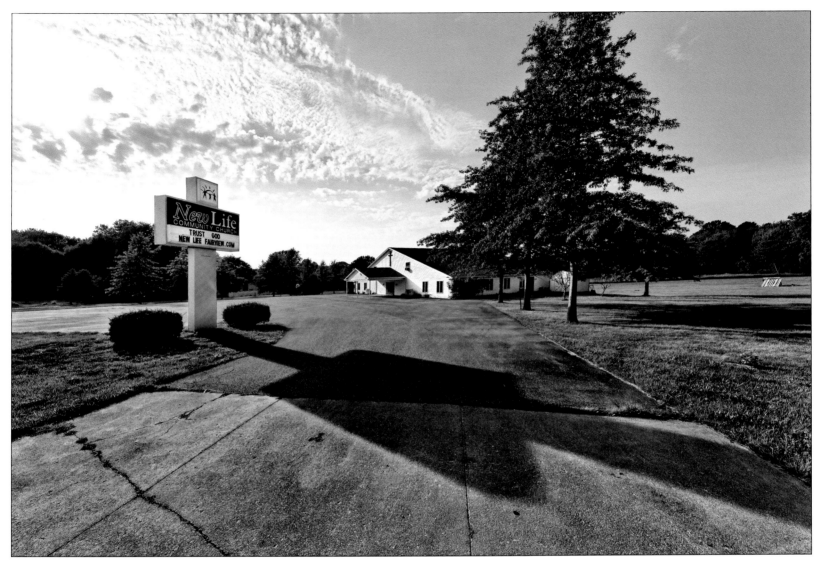

New Life Church – Avonia, Pennsylvania

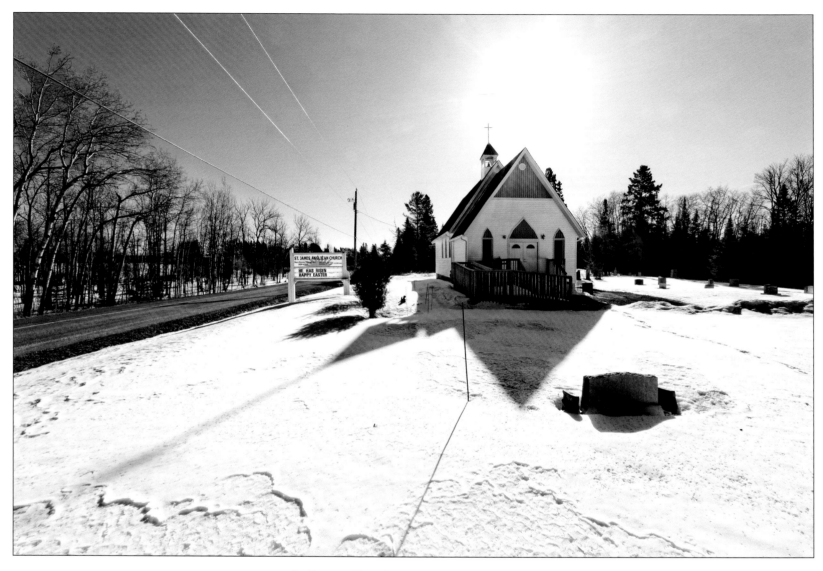

St. James Church – near Murillo, Ontario

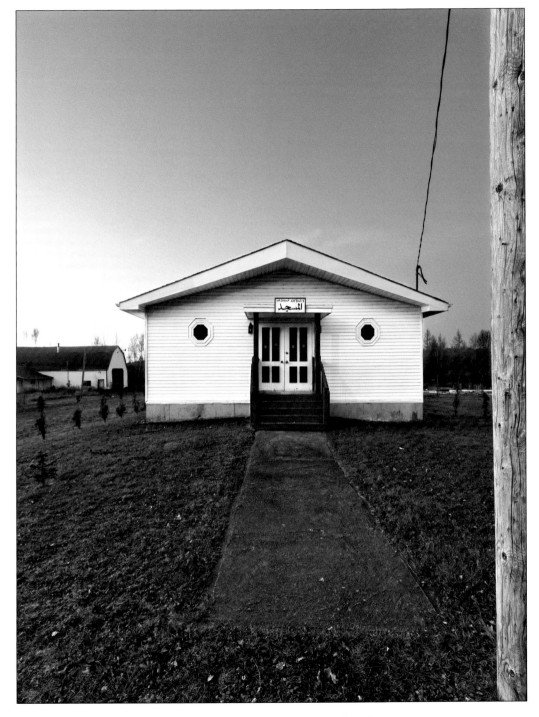

Truro Mosque – Truro, Nova Scotia

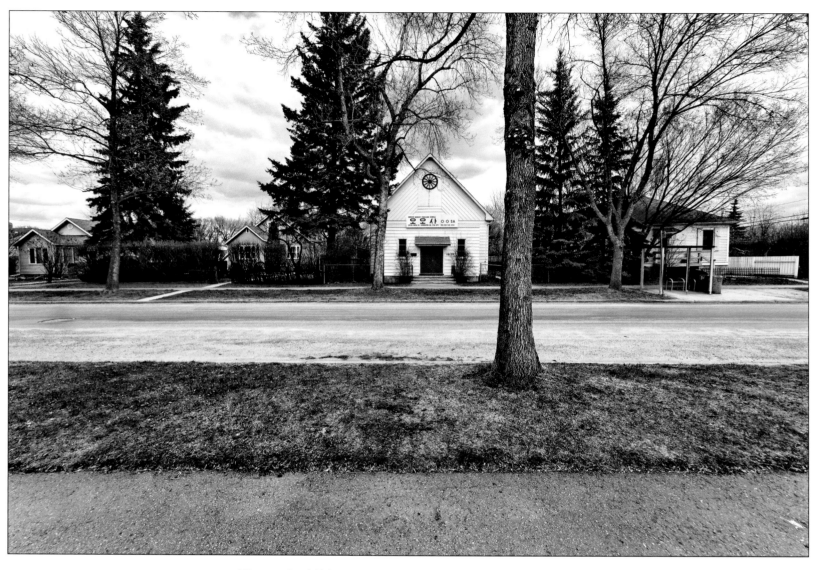

Korean Buddhist Pureland Temple – Edmonton, Alberta

Mark Schacter

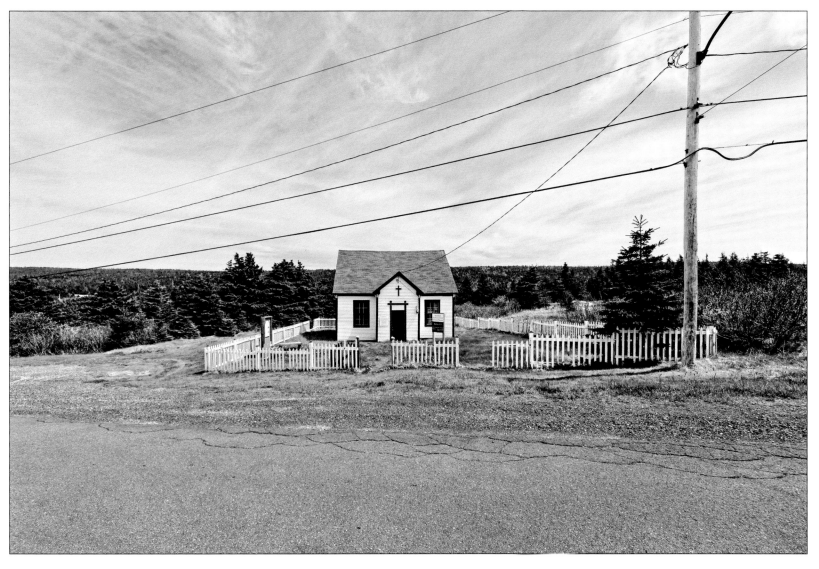

St. Joseph's Chapel – Blackhead, Newfoundland

St. Joseph's Chapel was originally built as a school in 1879, but the community began to use the building as a church as well after the nearby stone church fell into disrepair. The building continued in use as a school until 1965 and as a church until 1989. It is now a museum, and is a local rare surviving example of a small wooden chapel.

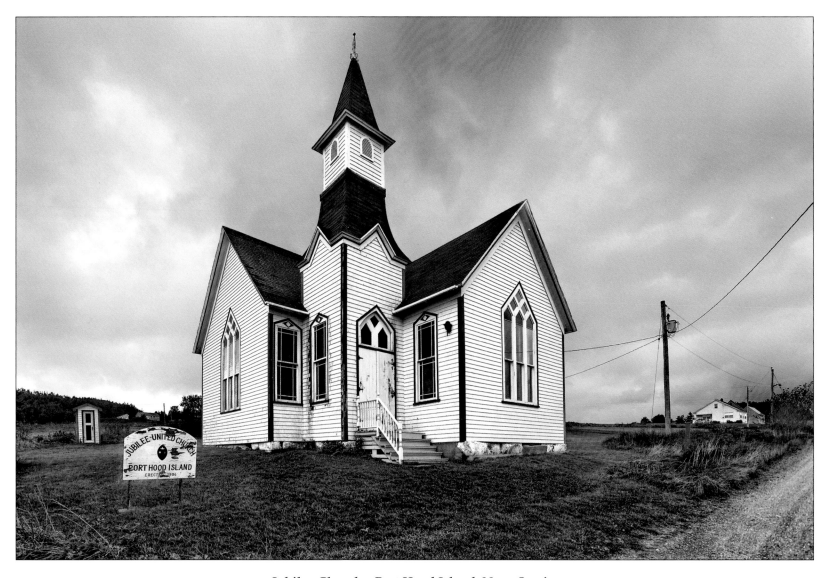

Jubilee Church – Port Hood Island, Nova Scotia

Window – Big Intervale United Church – Margaree Valley, Nova Scotia

A sign over the door of this isolated country church on Cape Breton Island commemorates the establishment of the congregation in 1828, however, the church itself was not built until 1868. In the early years of the nineteenth century, Scottish Presbyterian settlers in this part of Inverness County met in each other's homes when visiting clergymen made their rounds. The Church sits on the east bank of the Margaree River, an internationally renowned destination for salmon fishing.

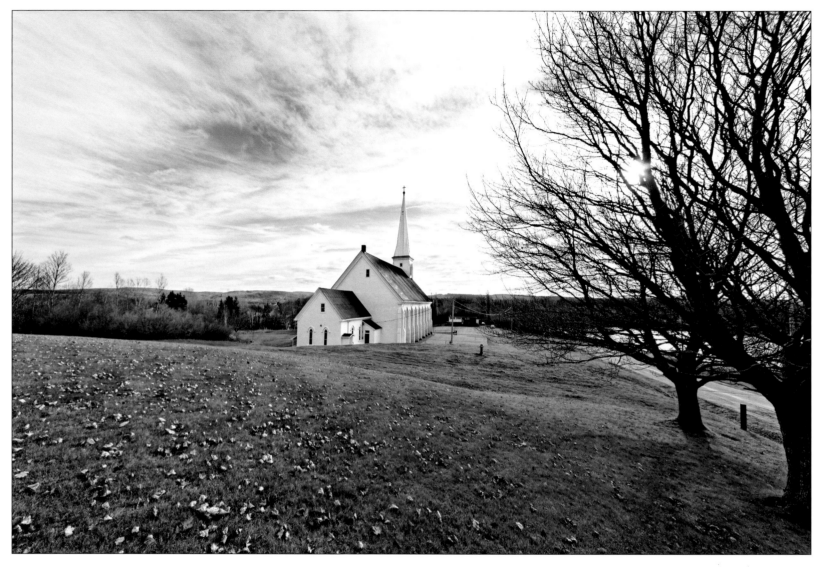

St. Mary's Church – Mabou, Nova Scotia

St. Joseph's Church – Little Bras d'Or, Nova Scotia

Nanaksar Gurdwara – Edmonton, Alberta

St. Edmund's Church – Big Valley, Alberta

St. Hughes Church – Sarsfield, Ontario

Mark Schacter

Rabbi Dan Korobkin

Beth Avraham Yoseph of Toronto Synagogue

Mark Schacter:

What is the significance of the house of worship to the experience and practice of the Jewish faith?

Rabbi Korobkin:

In Judaism, we believe that human beings cannot be completely abstract in their thought. We live in a material, physical world and we think concretely; we think in physical terms. When we want to have an association with abstract, non-material things, we sometimes enable that association by creating physical icons and symbols to surround us in order to enhance our ability to connect with those things that are spiritual or ephemeral and ethereal. So that's really the reason why a synagogue—a house of worship—is important in Judaism. This goes back to the very founding of our religion.

Judah Halevi, in the 12th century, wrote that the reason God told Moses to ascend Mount Sinai to receive the Tablets was that He knew that the Jews, having just

McDougall Memorial United Church – Morley, Alberta

Built in 1875 and restored in the 1950s, the church is linked to early missionary efforts and pioneering settlement in southern Alberta. The Morleyville Mission, of which the church was a central element, was the first permanent Protestant mission in the region, focusing its efforts on the Mountain Stoney aboriginal people living along the eastern slope of the Rocky Mountains.

emerged out of Egypt and being unfamiliar with a non-material, invisible God, needed some kind of physical icon to associate with that God. And that's why He told Moses to come down with a set of Tablets. Those Tablets represent a physical tether to that which is beyond the physical realm. And that will be the connection to the Divine. That's precisely why, when Moses tarries, as is recorded in the Book of Exodus, the Jewish people constructed the Golden Calf. It wasn't because they were trying to rebel and reject God for some other foreign god. It was because without the physical icon that they were hoping for, they felt they had nothing that symbolized their association with God.

Mark Schacter:

So we need some kind of physical representation because we are fundamentally tactile and can't live entirely in an abstract world. And yet, one of the core tenets of Judaism is that one must not worship idols.

Rabbi Korobkin:

That's precisely the point that Judah Halevi is trying to convey—the subtlety of the prohibition of idolatry. It's okay for us to have a set of Tablets, okay for us to have a Tabernacle where, we are told, between the cherubs resting on the Ark cover, the Divine presence rests—all that is fine. We just can't have a representation of God Himself. We have a representation of God's residence; we have a representation of gifts that come from God, but not a physical representation of Him.

Mark Schacter:

Perhaps this is a related point. Some congregations invest large amounts of money and time in building beautiful houses of worship. To what extent might that also be going down the wrong path in that it may focus attention on the material artifact in its own right?

Rabbi Korobkin:

The truth is that there's a tension. We look at Chapter 8 of the Book of Kings where we read about the construction of Solomon's Temple. We look at the latter part of Exodus and read about the construction of the Tabernacle. We see that tremendous care is put into every single detail. Precious metals—gold and silver and copper—and precious stones are used in such construction. Human beings are inspired by the holiness they feel in a place they perceive to be important and exalted. People genuinely feel different in a place where the lighting is bright, the walls are clean, and the floor is marble than they do in a poorly lit, dirty shack. That's the reason why it *is* important to beautify a house of worship.

But we have to put everything in its proper context. When it comes to the building of a Jewish community we have to know how to allocate funds properly when resources are limited. If we are going to pour all of our resources into the house of worship at the expense of the Jewish school where we are going to educate our children, at the expense of charity for the poor, then, of course, our priorities are misplaced. But if we are able to build something beautiful to inspire people to holiness, then we are supposed to do it.

St. Malachy's Church – Kinkora, Prince Edward Island

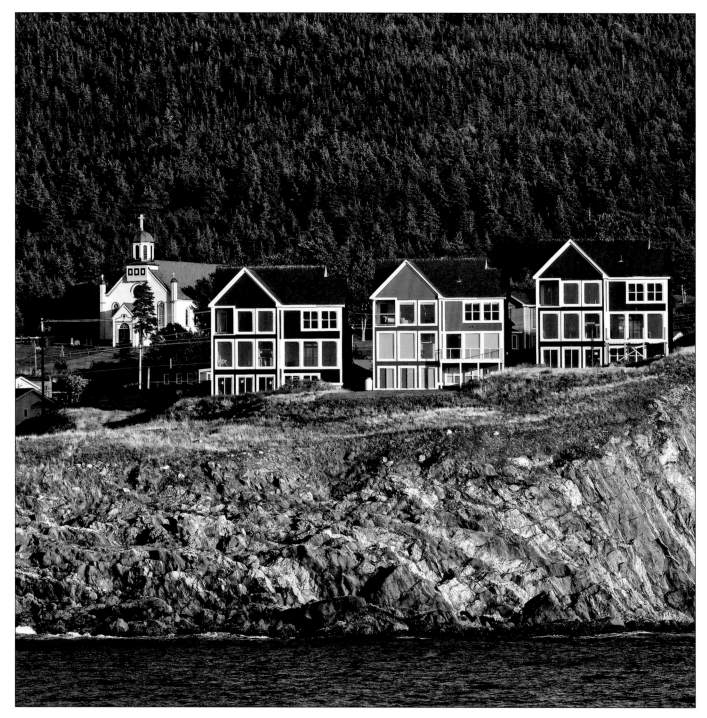

Holy Rosary Church – Portugal Cove, Newfoundland

Mark Schacter

Mark Schacter:

Does the concept of "sacred space" have resonance in Judaism, particularly in relation to the synagogue?

Rabbi Korobkin:

Yes, absolutely. We ascribe sacredness or holiness to the sanctuary of a synagogue. A person entering the synagogue is supposed to recite a verse, "How goodly are thy tents, O Jacob," acknowledging that a new sphere of reality has just been entered, and that some Godliness is to be ascribed to this place. It's one of the strange anomalies of our religion that, while we assert that God cannot occupy any kind of spatial confinement, at the same time the Torah itself says that God's presence rests between the two cherubim on top of the Ark cover. So there is this paradox: God is completely non-material, but we can concentrate His presence or make His presence more greatly felt in one place than in another. And that is what we try to capture in the sanctuary.

Mark Schacter:

In a synagogue, what is it precisely that makes the space "sacred"?

Rabbi Korobkin:

It's a combination of factors. One is the Ark. You are immediately struck by the Ark that contains the Torahs. But another is the very fact that it has been designated as a place to gather for prayer. This in itself makes the space holy. The Talmud says that any time ten

people gather for prayer the Divine Presence comes down and rests between them. So, to have a structure that is constructed for that purpose means that there is Godliness that dwells in that place more than in any other structure in the community.

Mark Schacter:

What if I just have ten people praying in my living room?

Rabbi Korobkin:

Then the Divine Presence is temporarily there. But if a person has the option of attending prayers in someone's living room or in a synagogue, the synagogue should be chosen because an intrinsic holiness exists there.

Mark Schacter:

Given the significance in Jewish history of the destruction of the Temple in the year 70 CE, can you comment on the significance of the synagogue in relation to community identity and cohesion?

Rabbi Korobkin:

The word for *synagogue* in Hebrew is *beth haknesset* which means "house of gathering." It does not mean "house of prayer."

It's certainly true that Jewish history has seen an evolution in the purpose and use of a synagogue, from before to after the destruction of the Temple. We have historical data showing that there were synagogues in communities even when the Temple was standing. Perhaps these

St.Thomas' Church – St. John's, Newfoundland

synagogues did not play as important a role as synagogues do today because the central place of worship and divine service was in the Temple in Jerusalem. Once the Temple was destroyed the synagogue became not only a gathering place where Jews could come together as a community, but also a place for prayer and religious expression. It remains the fact that in our tradition a synagogue is not meant exclusively as a place for prayer; it is also meant for study and for social gatherings in a venue that implies sacredness. Even when we have a social event in a synagogue there is a certain element of sacredness added to it because it is happening in a holy place.

Mark Schacter:

I have noticed that most synagogues I have seen in Canada and the U.S., when compared to, say, churches or mosques or Buddhist temples, tend to be very plain-looking structures, at least from the outside. Is this because, for so long, Jews in the diaspora felt threatened and so didn't want to have houses of worship that would make them stand out?

Rabbi Korobkin:

That's the conclusion that I would come to. The Temple, we are told, was the most beautiful edifice of its time. There's no reason why a synagogue should not be beautiful from the outside, but that would make it conspicuous. Traditionally, we have taken a low profile in the diaspora.

Mark Schacter:

Thank you.

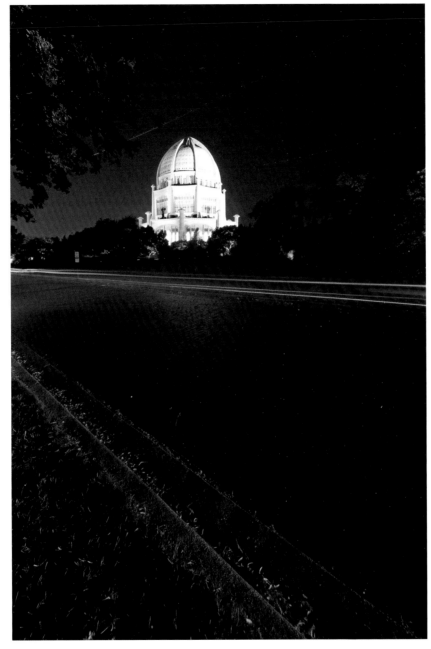

Bahá'í Temple – Wilmette, Illinois

Located on the shore of Lake Michigan just north of Chicago, this is one of only seven Bahá'í temples in the world. It opened in 1953 after more than thirty years of construction. When Canadian architect Louis Bourgeois revealed his model of the Temple in 1920, one New York newspaper wrote that "some go so far as to say it will be the most beautiful structure ever erected."

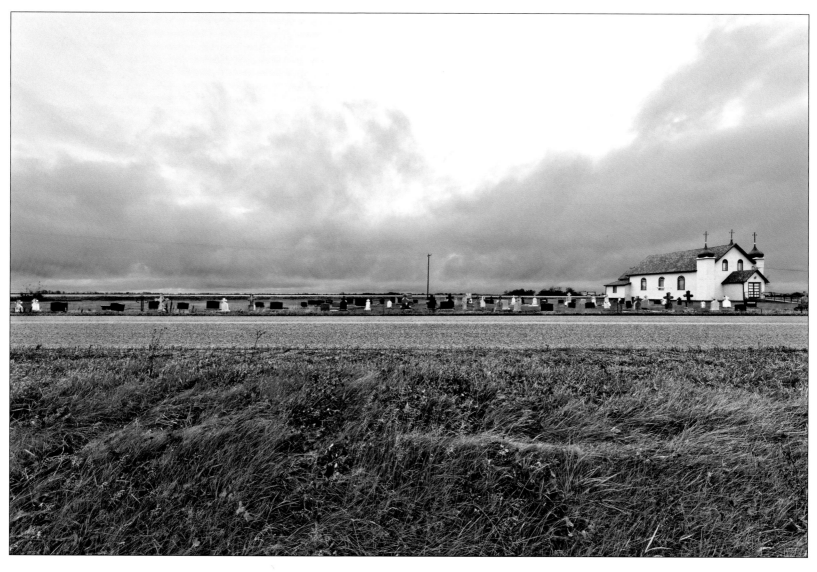

St. John the Baptist Church – Fork River, Manitoba

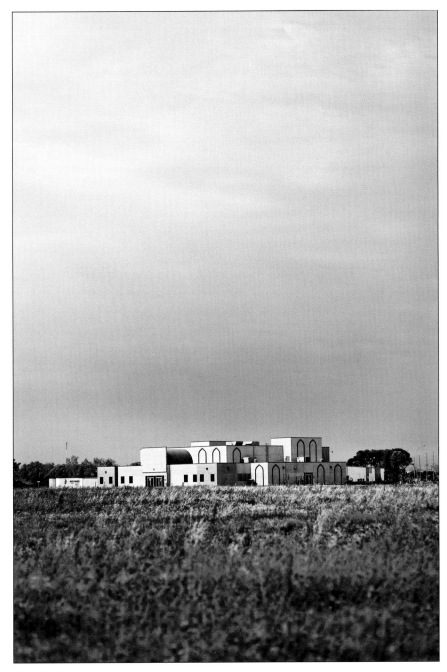

Winnipeg Grand Mosque – Winnipeg, Manitoba

Manitoba's Muslim population has grown rapidly in recent years; it now totals approximately twelve thousand. (By comparison, it is estimated that there were only twenty-five Muslim families in the province in 1966.) The Winnipeg Grand Mosque, which opened in 2007, is the main mosque in Manitoba.

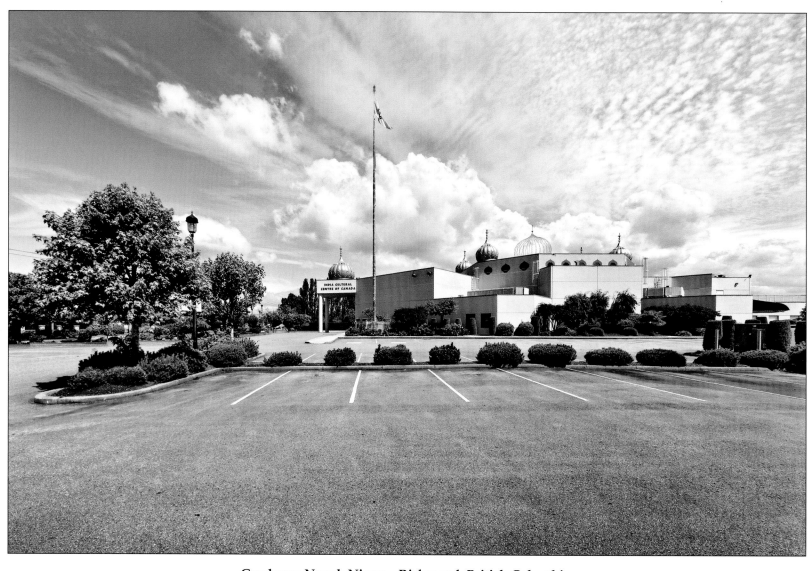

Gurdwara Nanak Niwas – Richmond, British Columbia

Gurdwara Nanak Niwas opened in 1993. The flag that flies on a tall pole outside it and every gurdwara (Sikh house of worship) is the nishan sahib.
It is a triangular flag, either yellow, orange, or blue. It serves as a beacon announcing to distant observers the presence of a gurdwara. It is also a sign of spiritual and temporal freedom and sovereignty. The nishan sahib, which is considered sacred, is taken down every year during the festival of Baisakhi and replaced with a new flag.

Protection of the Holy Virgin Church – Ottawa, Ontario

Jamia Mosque – Las Vegas, Nevada

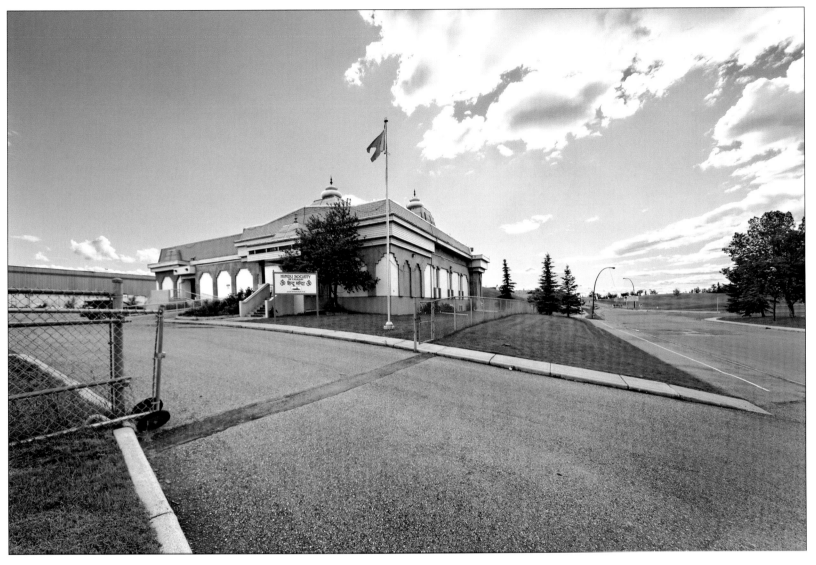

Hindu Society of Calgary – Calgary, Alberta

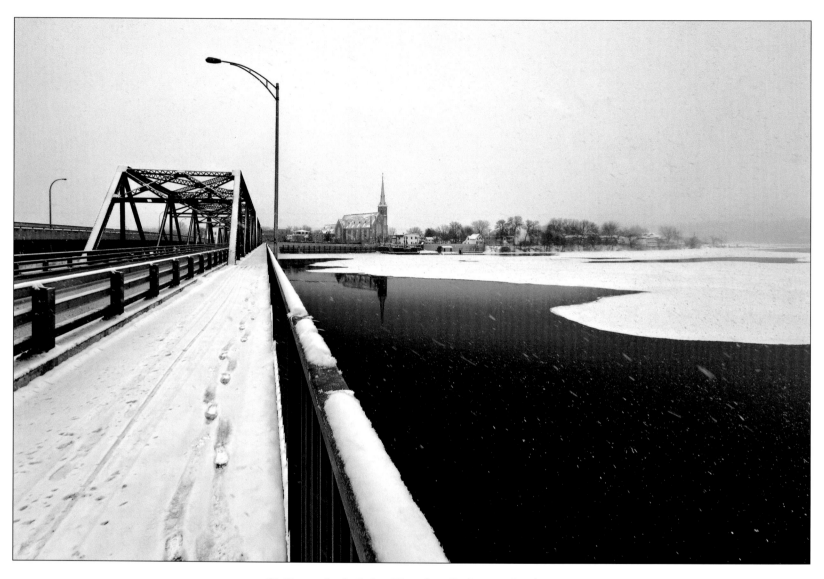

St. François de Sales Church – Gatineau, Quebec

United Church – Dorchester, New Brunswick

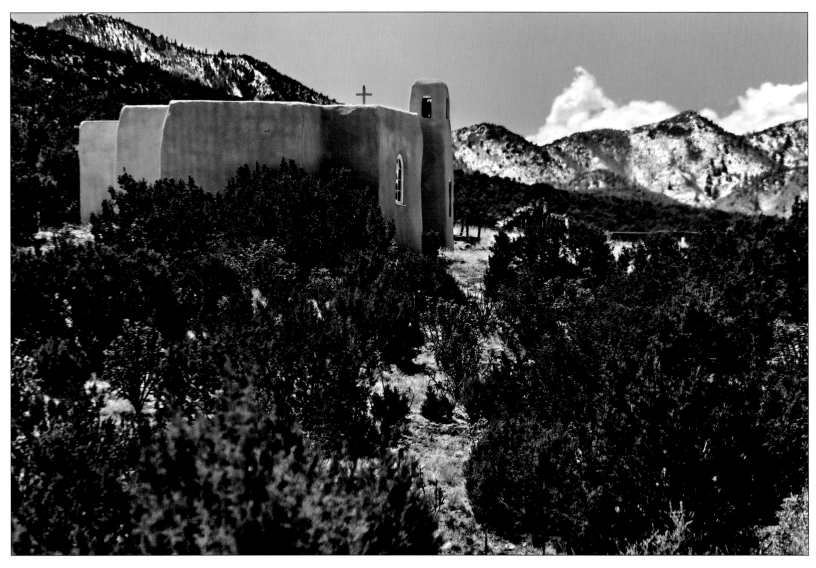

San Francisco Church – Golden, New Mexico

Golden was, in the 1820s, the site of the first North American gold rush west of the Mississippi River. But the goldfield turned out to be less rich than anticipated, and by 1928 Golden was a ghost town. San Francisco Church was built in 1830 and restored in 1960.

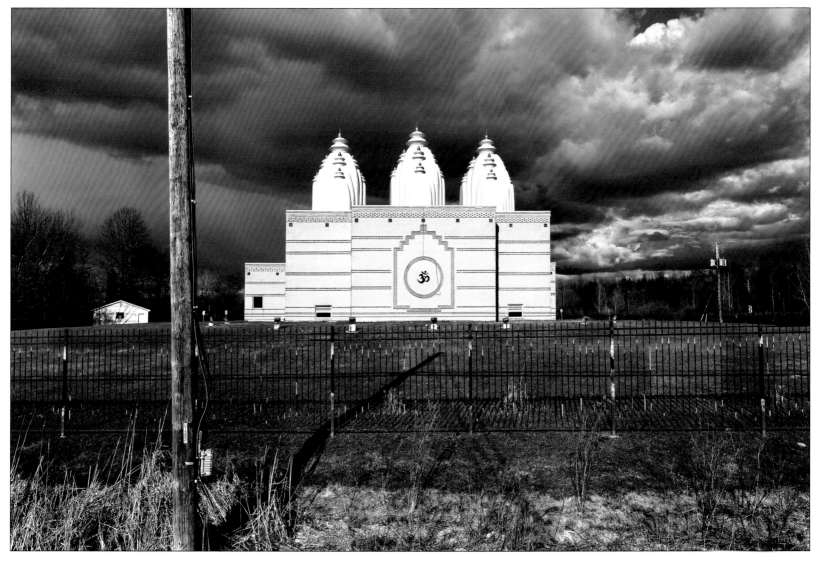

Hindu Temple of Ottawa Carleton – Ottawa, Ontario

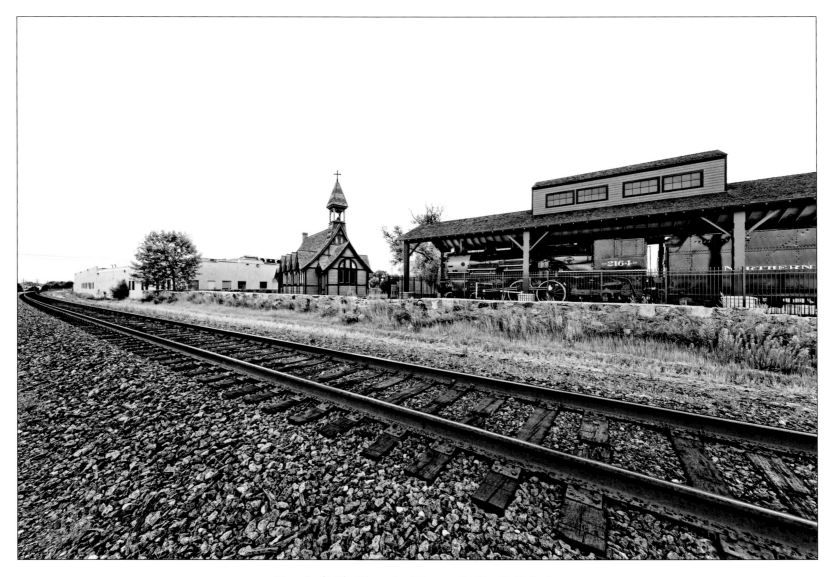

Bread of Life Church – Bismarck, North Dakota

Mark Schacter

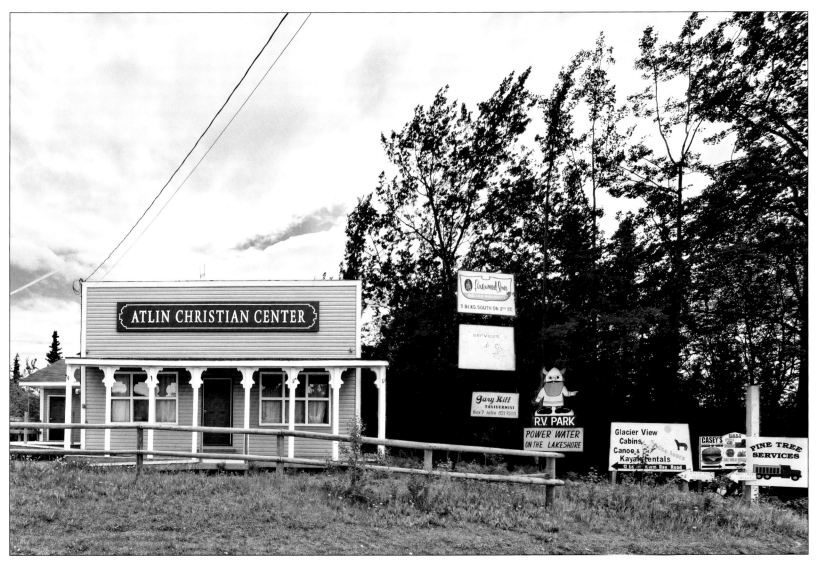

Atlin Christian Center – Atlin, British Columbia

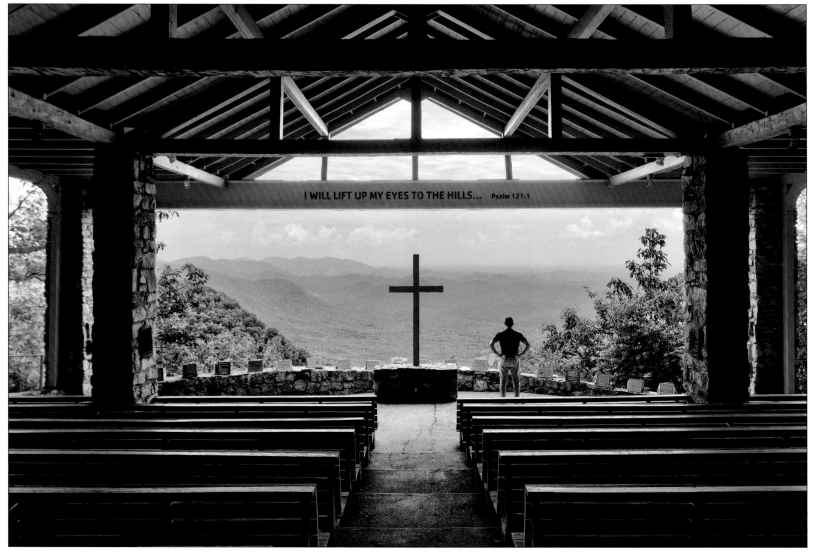

Fred W. Symmes Chapel, "Pretty Place" – near Cleveland, South Carolina

The Chapel, part of a YMCA camp, sits at the edge of a cliff about a thousand metres above sea level in the Blue Ridge Mountains.
It was constructed in 1941. It is also known as "Pretty Place" due to its magnificent view.

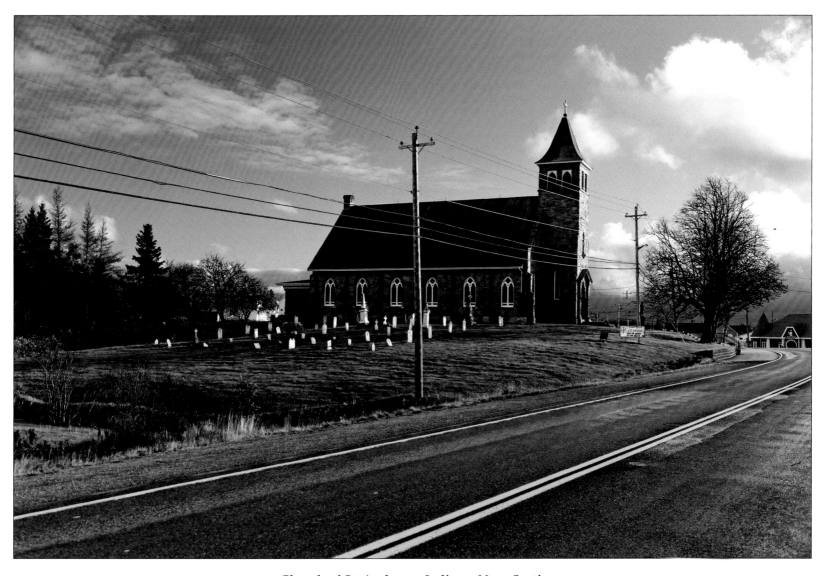

Church of St. Andrew – Judique, Nova Scotia

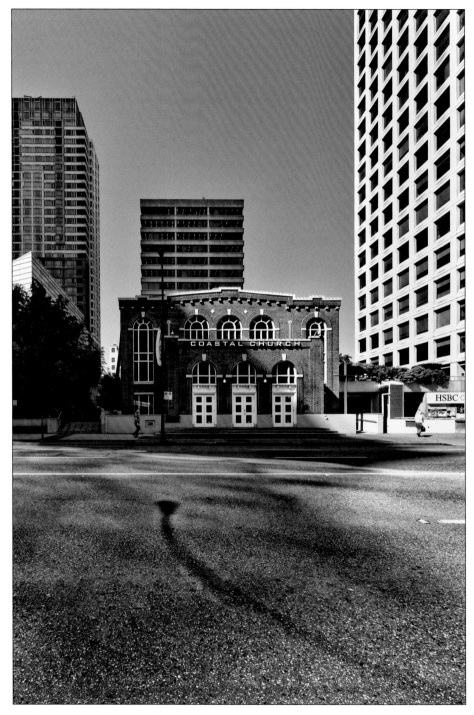

Coastal Church – Vancouver, British Columbia

Beth El Synagogue – St.John's, Newfoundland

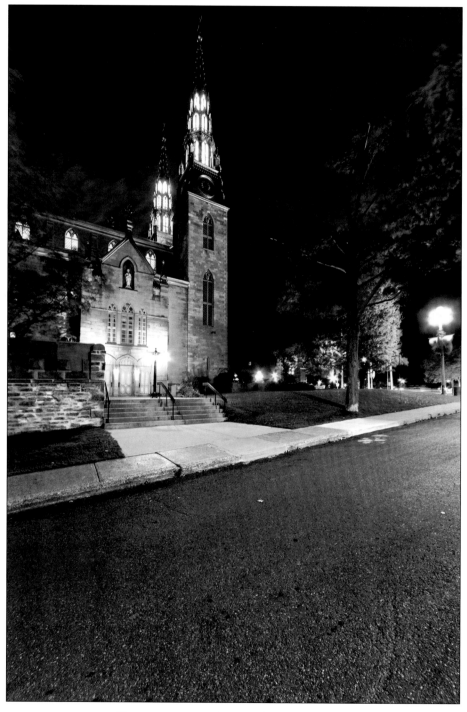

Notre Dame Basilica – Ottawa, Ontario

Mark Schacter

Father Michael Busch

Rector, St. Michael's Cathedral, Toronto, Ontario

Mark Schacter:

What is the role of the building itself in the experience of faith?

Father Michael Busch:

I look at that question from where I am—a Cathedral—which is perhaps different than a normal church. It has a different role; it has a different set of priorities. In fact, strictly speaking, in each diocese the Cathedral is considered to be the only "church." Every other house of worship in the diocese is, in fact, a "chapel" of the Cathedral.

So a Cathedral, first and foremost, is the seat of the bishop. It's the physical place where his chair, which symbolizes his power, is located. The chair sits in the main sanctuary; everybody can see it. It reminds us of our Shepherd. That's one of the first things that a Cathedral does.

The other thing it does is that it gathers the entire community of a diocese to itself:

all the major important rituals of the church are done there: the Easter vigil, the ordination of priests.... It's a centre for anyone in the diocese to come and see how things should be done properly.

As for the building itself—again, I'm thinking of a Cathedral specifically—the point of the building is to leave people feeling awestruck. We are trying to draw people in. I think about the story of a man who came into our Cathedral one day. While he was there he saw a pamphlet about how to become a priest. And then he eventually became one. And it seems to me that that would never have happened had it not been for the building itself—it was the building that drew him in in the first place.

Mark Schacter:

Faith is non-material. A Cathedral, with its stone and windows and decoration, is very much a thing of the material world. How do you reconcile these two ideas?

Father Michael Busch:

This is a question I think about all the time, especially as we are now in the midst of an extensive renovation of the Cathedral. As we make each decision in the renovation I have to think about: At what point am I honouring the building as opposed to honouring God?

The point is that the building should trigger your spirituality; anything beyond what is necessary to do that is a distraction. It's a question of finding the right balance. But it must never be just about the construction. The intention behind the construction is to inspire

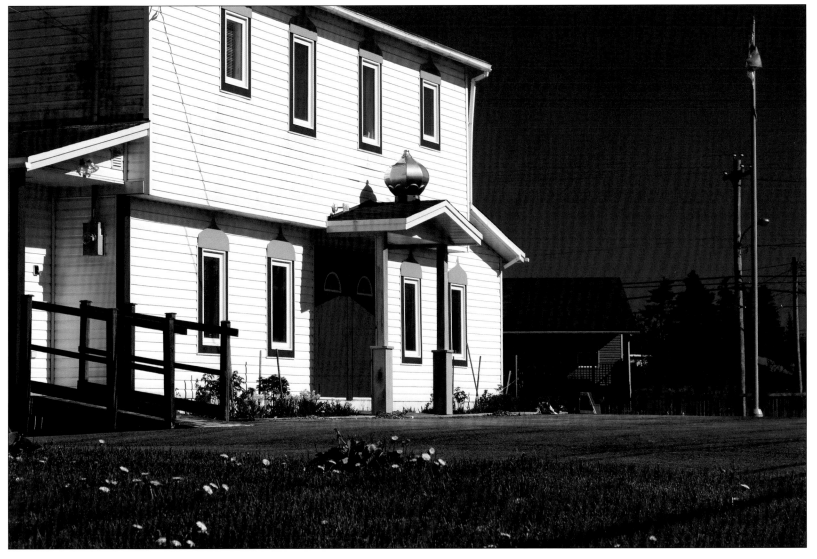

Newfoundland Sikh Society Gurdwara – Logy Bay, Newfoundland

people to serve God and to serve other people. By honouring God—and one of the ways to do that is through the creation of beautiful buildings—we learn about service to others.

At the end of the day we are human, and we need symbols. We need things that we can see and touch. We need to see physical beauty in order to get past it.

Mark Schacter:

What makes a space "sacred"?

Father Michael Busch:

I think it is quietness—a sense of separation from the day-to-day. You become aware that your daily world may not be as important as you think it is. It's a feeling that "Here, I sense something else." It is an awareness that in this space there is faith and history and the people who built this. This brings us back to your question about the role of the building itself—its role is to separate you, for a time, from the concerns and sensations of everyday life. It provides you with a place where you can feel the sacred, which is not something you get at home or at your office.

For me, personally, I get a spiritual boost out of sitting in the Cathedral when it is dark and empty and quiet. I think about the fact that it is a 168-year-old building and about all of the people who have prayed here. So you could also say that constant use is what makes the space sacred—the prayers, over the years, of many thousands of people consecrate the space.

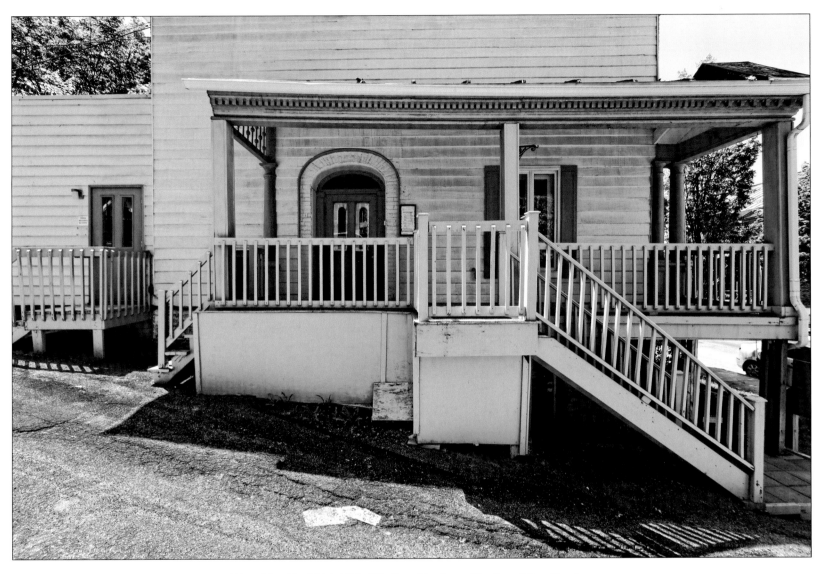

Toushita Buddhist Meditation Centre – Quebec City, Quebec

Mark Schacter:

Earlier in the conversation you said that the Cathedral is the only church in every diocese, and that the other houses of worship are chapels of the Cathedral. So the buildings themselves are also a physical expression of the organizational structure of the Catholic Church.

Father Michael Busch:

Yes. They reflect the earthly hierarchical structure of the Church. They symbolize the governance of the Church and its institutional permanence. They remind us of the underlying earthly framework that makes it possible for the Church to be a vehicle for faith and spirituality. The buildings embody the combination of the human and the Divine, and so, in a way, they are also a symbol of Christ himself.

Mark Schacter:

Is there anything else you would like to add?

Father Michael Busch:

I think about the first Bishop of Toronto who began construction of our Cathedral in the mid-1800s, at a time when Toronto didn't even exist. It was just the small settlement of York. Back then, the notion of an imposing Cathedral seemed outrageous to some. But he was not building just for the present. He foresaw a structure that would speak to future generations of the faith of the people who built the diocese, and who would continue to build it long after his life was over. And so this building is the manifestation of a

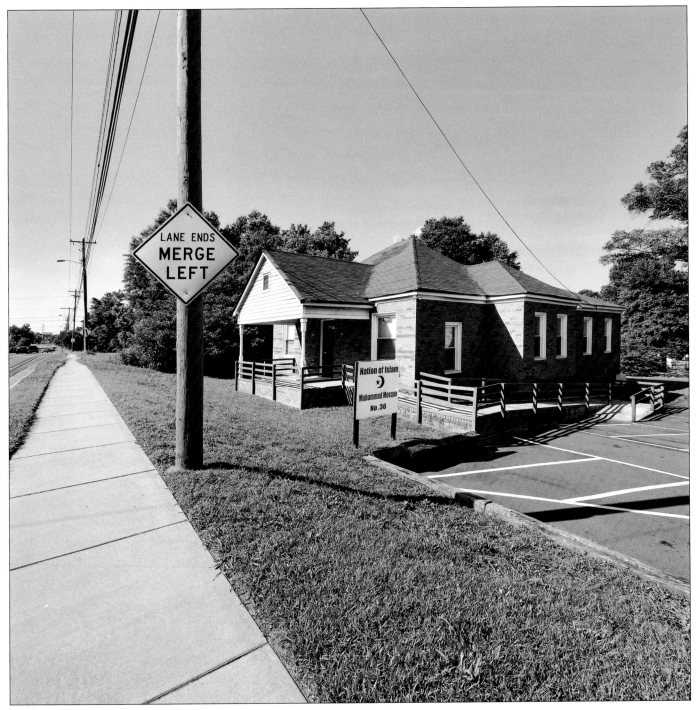

Nation of Islam Muhammad Mosque No. 36 – Charlotte, North Carolina

vision that has inspired so much—hospitals and schools and all the other good work the Church does here.

Mark Schacter:

Thank you.

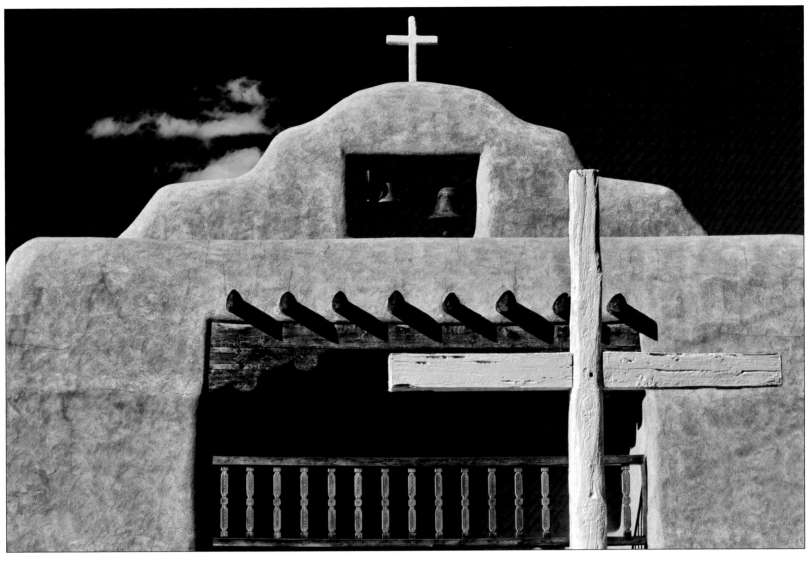

St. Thomas the Apostle Church – Abiquiu, New Mexico

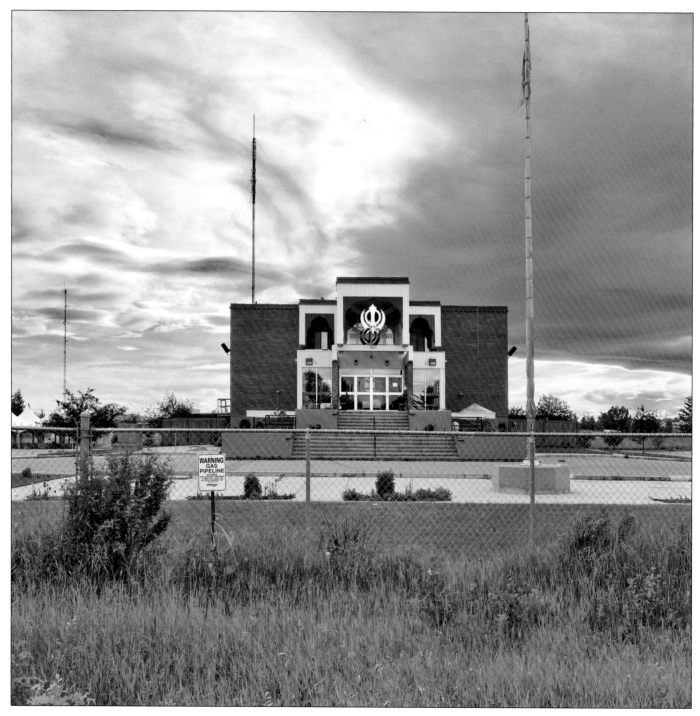

Sikh Society of Calgary Gurdwara – Calgary, Alberta

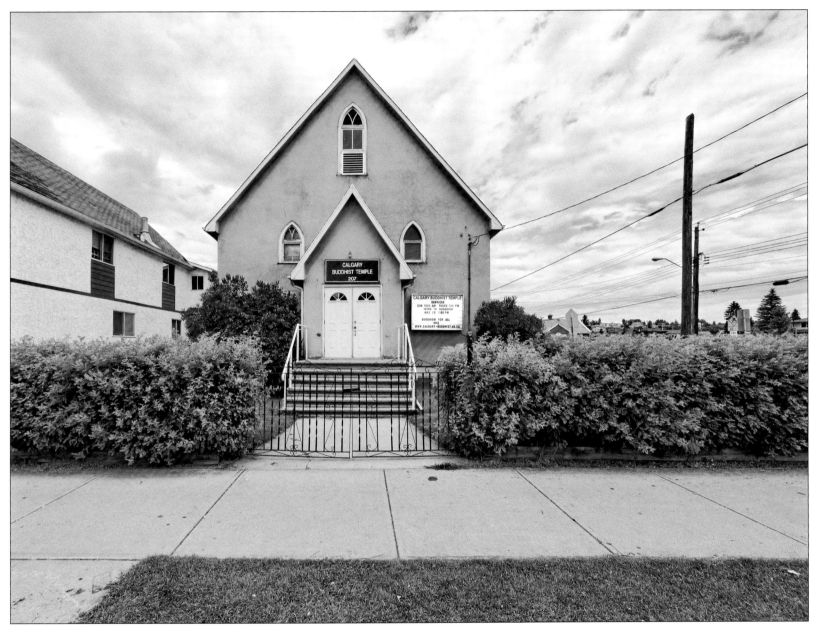

Calgary Buddhist Temple – Calgary, Alberta

Stone Church – St. John, New Brunswick

St. Luke's Church – Victoria, British Columbia

The founding of this church is linked to British Columbia's Cariboo gold rush, which began in 1861. A successful gold miner gave eight acres of land to the parish in 1862. This, together with a donation from Baroness Angela Burdett-Coutts, widely known as the "richest heiress in England," led to the construction of the parish's first chapel.

First United Presbyterian Church – Bismarck, North Dakota

Abandoned Church – Yellow Grass, Saskatchewan

Trinity Chapel – Ailsa Craig, Ontario

Mark Schacter

St. John the Evangelist Church – Kagawong, Ontario

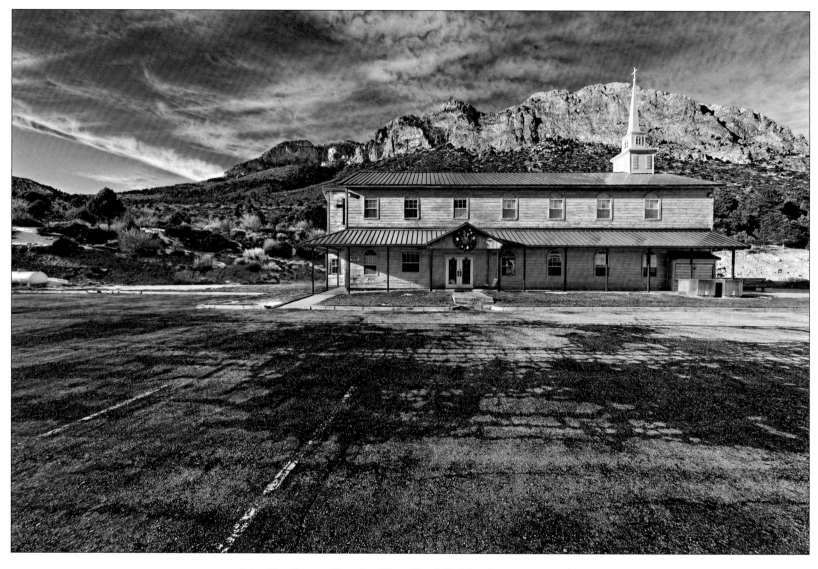

Mt. Charleston Baptist Church – Mt. Charleston, Nevada

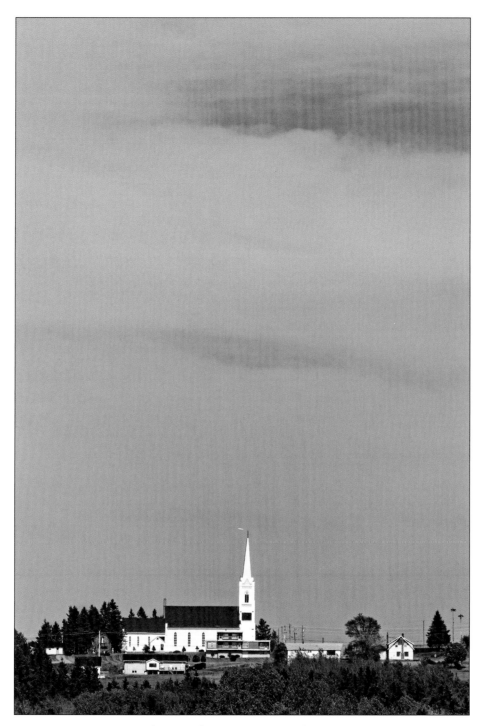

Norte Dame de Lourdes – Memramcook, New Brunswick

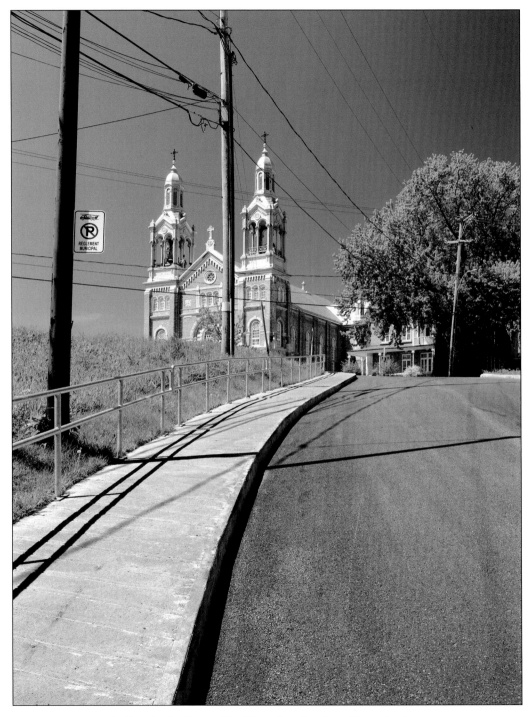

St. Louis de Courville Church – Quebec City, Quebec

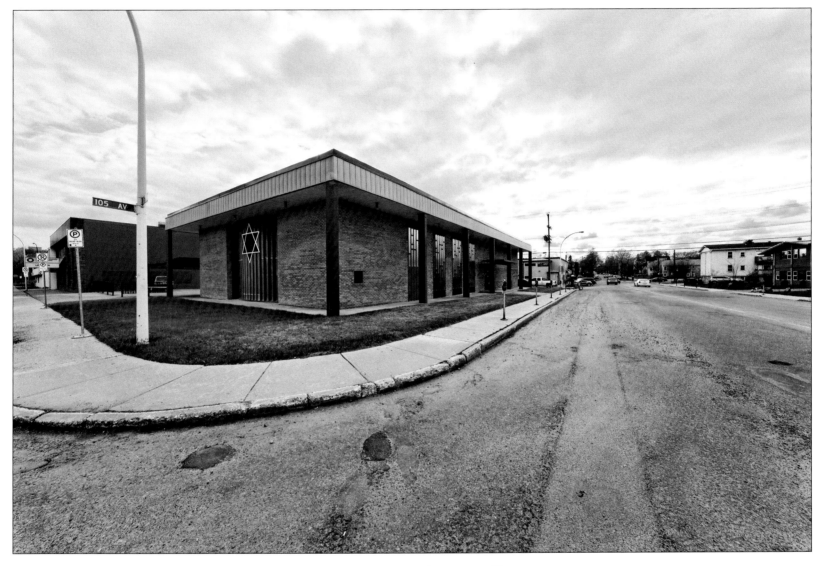

Temple Beth Ora – Edmonton, Alberta

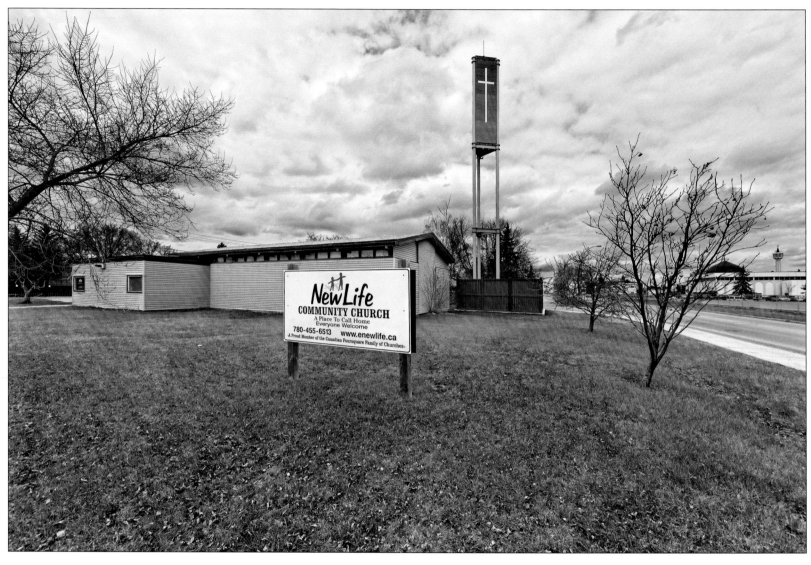

New Life Community Church – Edmonton, Alberta

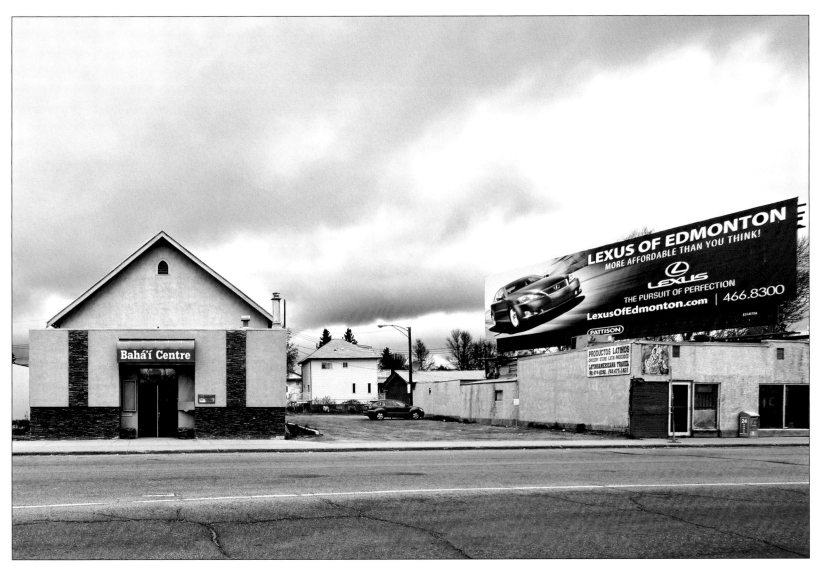

Bahá'í Centre – Edmonton, Alberta

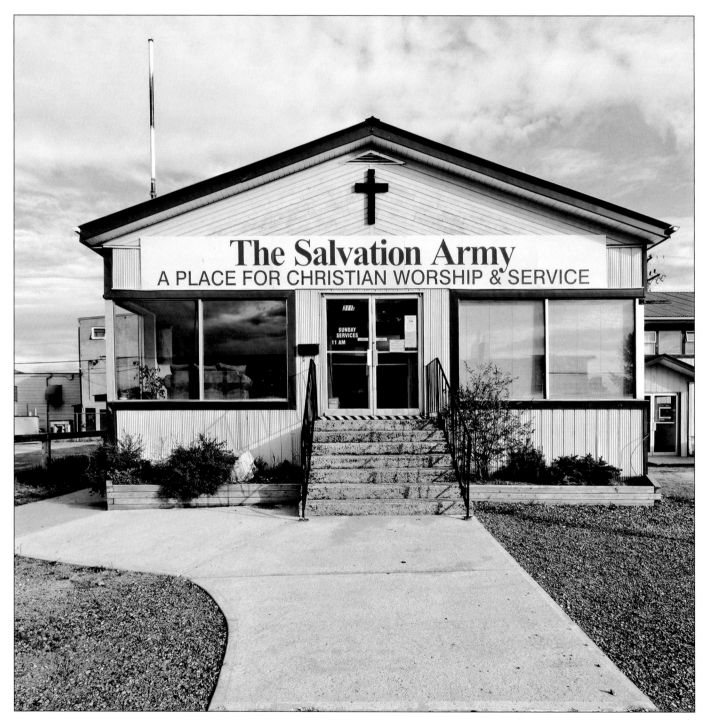

Salvation Army Chapel – Whitehorse, Yukon

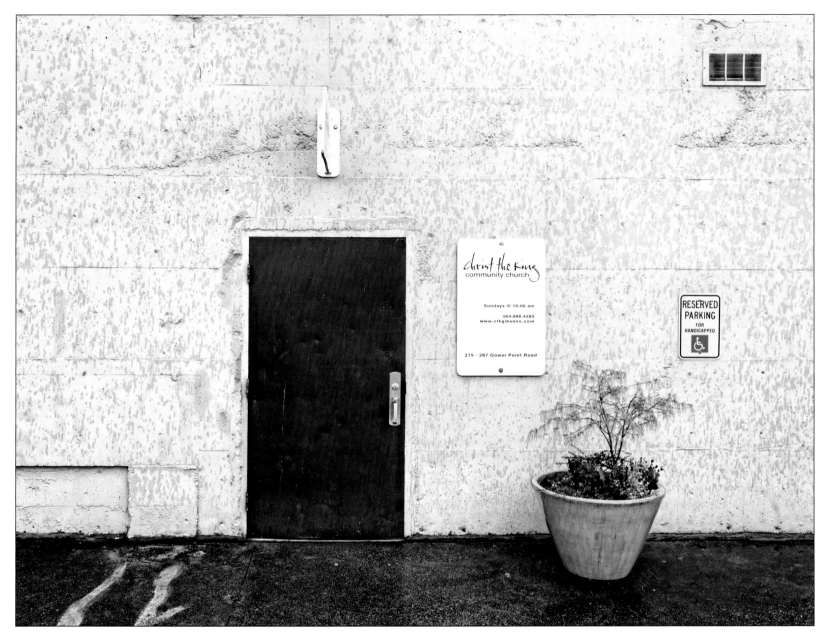

Christ the King Community Church – Gibbons, British Columbia

Dartmouth Mosque – Dartmouth, Nova Scotia

Mark Schacter

Thunder Bay Masjid – Thunder Bay, Ontario

Al Salam Mosque – Montreal, Quebec

Baitul Mukharram Mosque – Montreal, Quebec

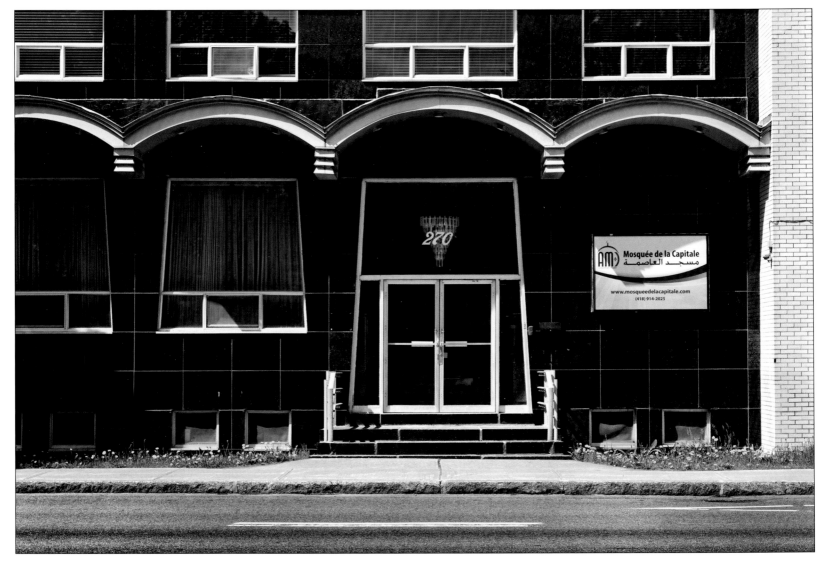

Capital Mosque – Quebec City, Quebec

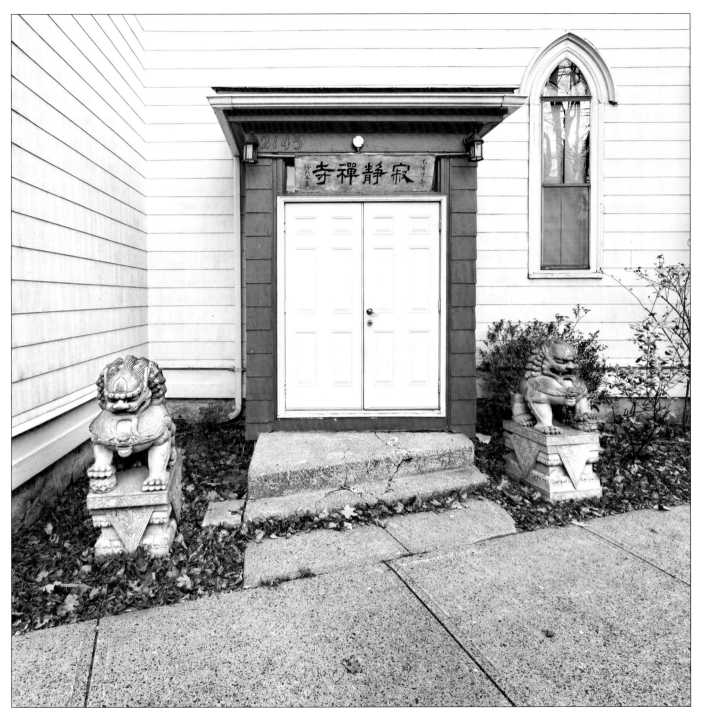

Ji Jing Chan Temple – Halifax, Nova Scotia

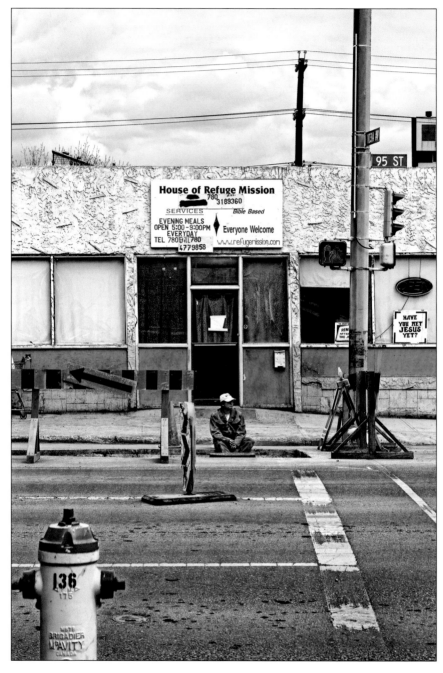

House of Refuge Mission – Edmonton, Alberta

Describing itself as a "Christ-centred, inner-city mission working with the homeless, poor, or the unfortunate," the House of Refuge Mission offers daily prayer services while also serving about a thousand meals every week. No one is turned away for being intoxicated, under the influence of drugs, or for mental illness.

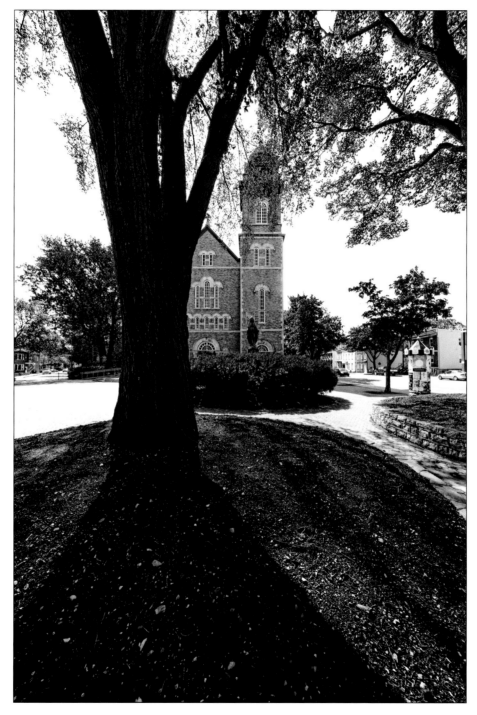

St. Malo Church – Quebec City, Quebec

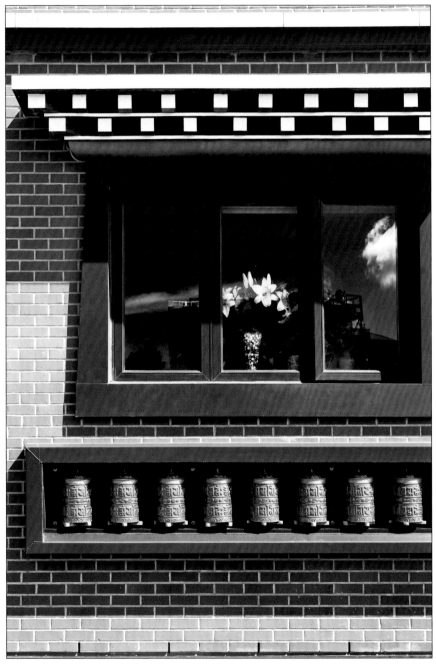

Prayer Wheels and Lilies, Thrangu Monastery – Richmond, British Columbia

This is Canada's first traditional Tibetan Buddhist monastery. It was opened in 2010 by the Very Venerable Khenchen Thrangu Rinpoche, the worldwide leader of Thrangu Monasteries. The Shrine Hall has a nine-meter-high ceiling and a four-meter-tall, gold-leaf-covered statue of Buddha.

Tu' An Temple – Ottawa, Ontario

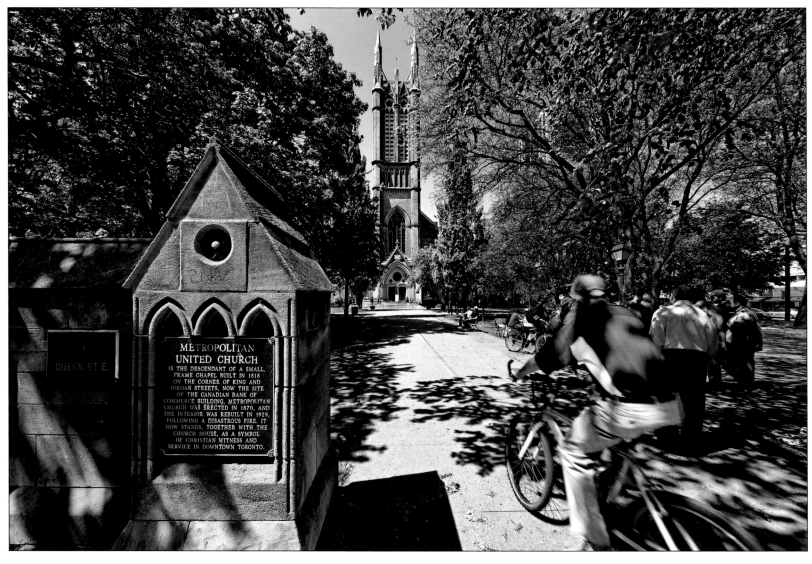

Metropolitan Church – Toronto, Ontario

Gatineau Mosque – Gatineau, Quebec

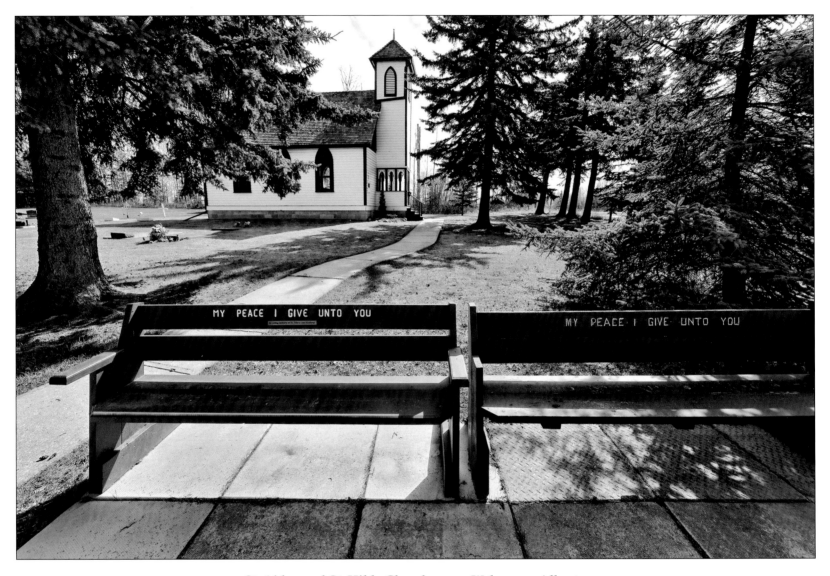

St. Aidan and St. Hilda Church – near Wabamun, Alberta

Most Reverend Fred Hiltz
Primate, Anglican Church of Canada

Mark Schacter:

Could we begin with your general view on the relationship of the house of worship to the practice of faith?

Most Rev. Fred Hiltz:

In most faith traditions, certainly the Judeo-Christian tradition, there is a clear sense that we should erect houses of worship in which we invoke the Divine presence to abide. The language we use—"House of the Lord," "House of God"—reflects that. We consider such buildings to be sacred because we believe that God is there. When you go inside you have a sense of the Divine presence. It's evoked through the design of the space, through the furnishings, through artwork and music. That isn't to say that we think the Divine presence doesn't abide everywhere. It does, but it dwells in the house of worship in a particular way.

Mark Schacter:

In what particular way is God present in a house of worship?

Most Rev. Fred Hiltz:

It's as if we trust that God will pay particular attention to our acts of devotion in the house of worship even though we know He is all-seeing and omnipresent. Solomon referred to this in his dedication of the Temple in Jerusalem:

> *But will God indeed dwell on the earth? Even heaven and the highest heaven cannot contain you, much less this house that I have built!*

> *Have regard to your servant's prayer and his plea, O Lord my God, heeding the cry and the prayer that your servant prays to you today; that your eyes may be open night and day towards this house, the place of which you said, "My name shall be there," that you may heed the prayer that your servant prays towards this place.*

> *Hear the plea of your servant and of your people Israel when they pray towards this place; O hear in heaven your dwelling-place; heed and forgive.[1]*

Mark Schacter:

You say that the "sacredness" of a house of worship comes from the presence of God. What about the presence of people in the space?

1. Kings 8:27-30 (New Revised Standard Version).

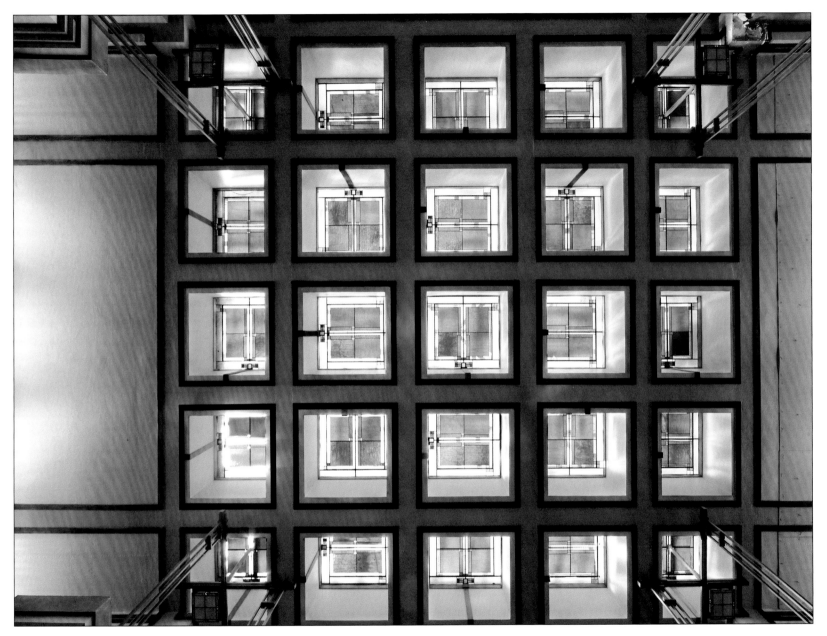

Skylights, Unity Temple – Oak Park, Illinois

Unity Temple opened in 1909. It was designed by the famed American architect Frank Lloyd Wright
(whose home was in Oak Park, a small city adjacent to Chicago), and is considered one of his most significant projects.
He designed not only the building, but also the stained glass and the furniture.

Unity Temple – Oak Park, Illinois

Most Rev. Fred Hiltz:

Houses of worship are places where people of God gather as a community. The space is sanctified by the devotion of the people who occupy it, who sing God's praises, listen to His word and are nurtured by it. We say about older buildings, "If the walls could talk…" Church walls have absorbed songs and prayers and incense over the years. The minute you walk in you feel a sense of respect for the Divine. You feel that the love of God continues to sanctify the space. I've heard people say that they feel enveloped by God's presence when they come inside a church. They are looking for shelter, a haven of Divine peace that can't be found anywhere else.

Mark Schacter:

How strong is the connection between practicing your faith and spending time in the house of worship? In other words, can you be considered a "good Christian" if you don't go to church?

Most Rev. Fred Hiltz:

I don't believe you can judge the depth or the quality of a person's faith on the basis of whether or not he or she goes to church. But I would encourage people to see that there is value in coming together with others who share their faith. I think that doing this both affirms and challenges your beliefs. Most importantly, one of the things you get from rubbing shoulders with others in church is encouragement to go and live your faith out in the world.

Mark Schacter:

Do you see a tension between the opulence of some houses of worship—construction materials, stained glass, statuary, etc.—and the notion that religious faith reminds us of the importance of transcending attachment to earthly material things?

Most Rev. Fred Hiltz:

We always live with that tension. What we have to remember is that a house of worship is erected to the glory of God. It's meant to give us a sense of "looking up"; the spaciousness of a grand building is a reminder of the spaciousness of God. (Having said that, I would also point out that I have been in churches where the only decoration was a cross, and there was beauty in that simplicity.) The building is not an end in itself. We need to always be asking ourselves: For what purpose do we maintain this place? We need to look at church buildings as being places where people gather and learn and take what they learn out into their communities.

There was an occasion when I was deconsecrating a church building, and I said to the parishioners, "we are deconsecrating the church building but at the same time we are renewing our commitment to be the Church out in the world." So the idea is that the church building serves a valuable purpose if it can encourage and inspire people to "be the Church" out in the world. Of course, the older the church building, the greater the temptation to maintain it, but we still have to ask: How does maintaining the structure contribute to serving God's mission in this community? When you have a church that's open for three

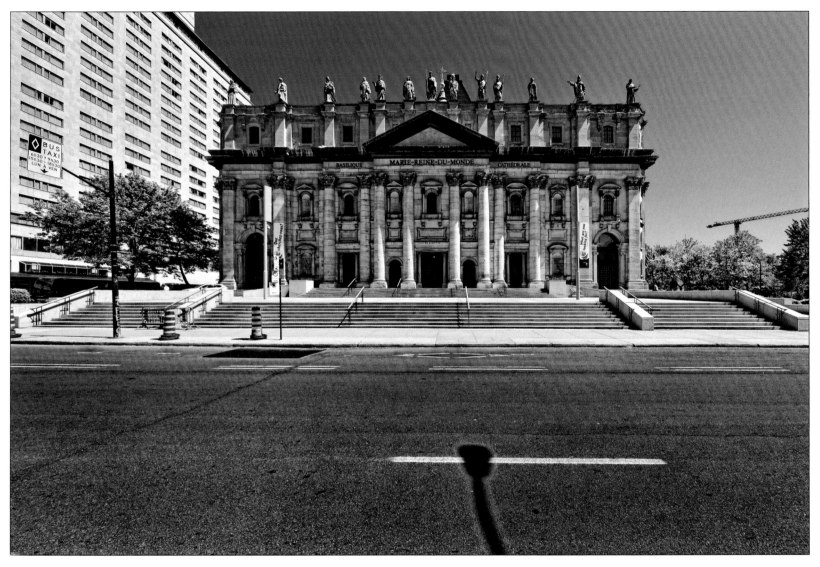

Mary Queen of the World Cathedral – Montreal, Quebec

St. John the Baptist Cathedral – St. John's, Newfoundland

Mark Schacter

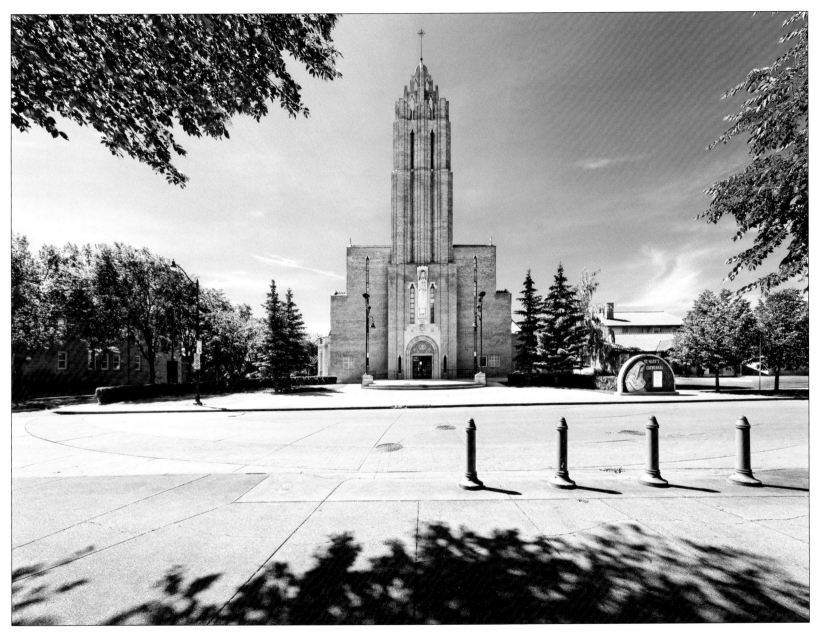

St. Mary's Cathedral – Calgary, Alberta

Al Salaam Mosque – Burnaby, British Columbia

hours a week on Sunday and is locked the rest of the time, you have to ask some difficult questions about what should be done with it.

Mark Schacter:

How are you approaching those "difficult questions"?

Most Rev. Fred Hiltz:

For one thing, we are completely rethinking the way that church buildings are used. They are becoming much more than places of worship. They are being used for community events, art festivals, and public meetings. A lot of churches are opening their doors for community outreach. Here in Toronto just a few blocks from my office, the crypt at St. Simon the Apostle Church is being used as a shelter for the homeless. At St. James Cathedral they had to move the Tuesday community "drop-in" out of the parish hall because it was undergoing renovation and so it was moved into the Cathedral itself. I walked in one Tuesday to have a look. The place was full of people—getting a free lunch, a hot meal, a haircut, having letters written for them.

We went through a time when church buildings were tightly locked up a lot of the time. Now the doors are open, and not just for prayer services.

Mark Schacter:

Does using the space for these purposes apart from worship run the risk of making the house of worship seem to be any less sacred?

Most Rev. Fred Hiltz:

Not at all. It is a demonstration of the Church doing God's work. We are supposed to love all of God's children: feed them, shelter them, and nurture them. Opening up church spaces to these kinds of activities is really what the Gospel is all about. If anyone is uncomfortable with using churches in this way, I would suggest to them that they take a closer look at the Gospel.

Mark Schacter:

We live in a time of declining formal affiliation with many brands of organized religion. Can the house of worship—the church building, in your case—become a focal point for bringing people back into the fold?

Most Rev. Fred Hiltz:

Yes it can. Through what we choose to do, or not to do, in our houses of worship, in how we use those places, we are compelled to ask ourselves questions about the kind of community we are and want to be. We have to ask ourselves how we attract people and whether or not we have done things in the past that may have driven people away.

One thing I do feel strongly about is that even in a world that is in some ways so "connected" thanks to technology, there are more and more people who feel completely disconnected from everything. In that context, I think that if people can see a connection between what goes on inside churches and what people do outside the walls of the church,

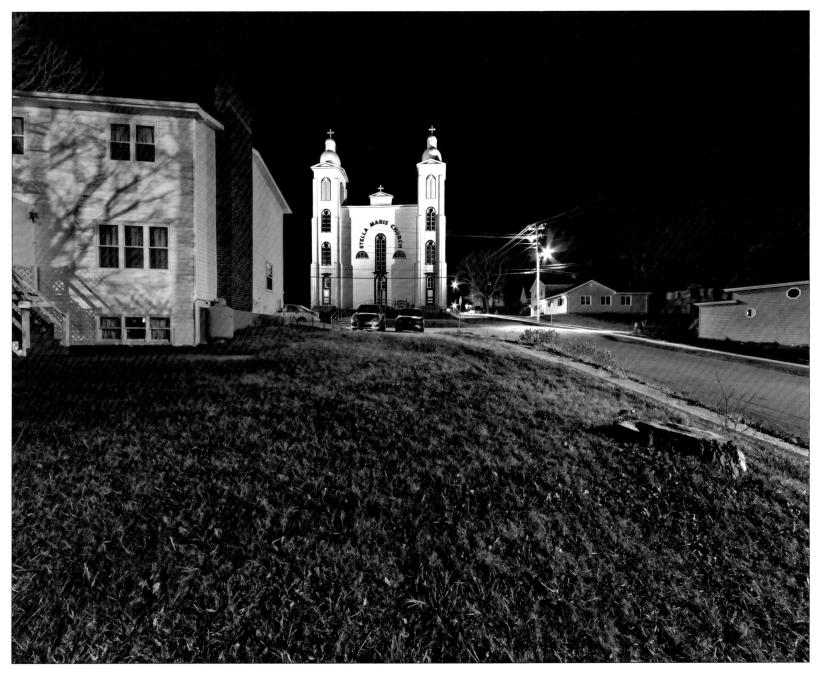

Stella Maris Church – Inverness, Nova Scotia

they will be attracted to come in. There has to be a connection between faith on the one hand, and good works on the other. People want to have a faith experience that enables them to make a difference out in the world. If they can experience a building full of people who share that same wish, then they may well have found a spiritual home.

Mark Schacter:

Thank you.

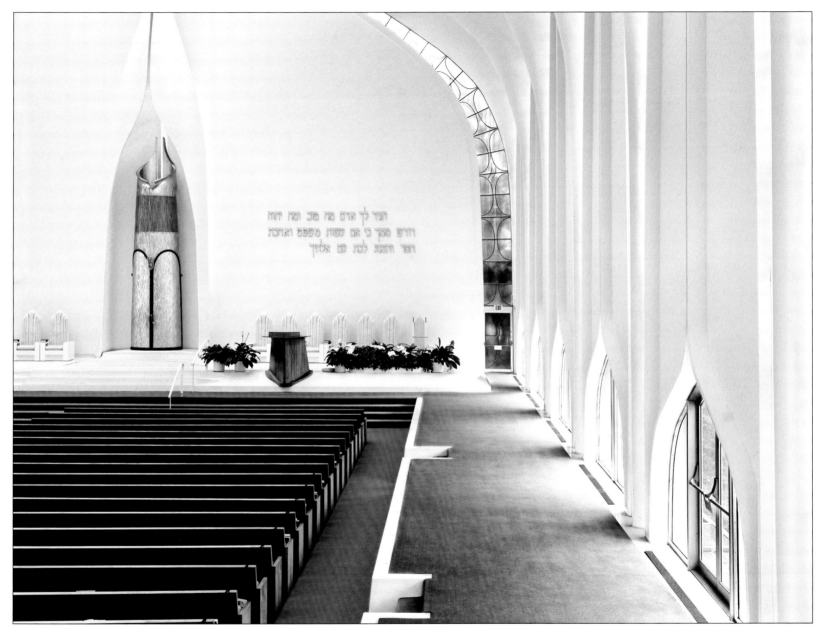

North Shore Congregation Israel Synagogue – Glencoe, Illinois

This synagogue was designed by Minoru Yamasaki, the same architect who designed the Twin Towers of the World Trade Center in New York City, destroyed by terrorists on September 11, 2001. The synagogue opened in 1964.

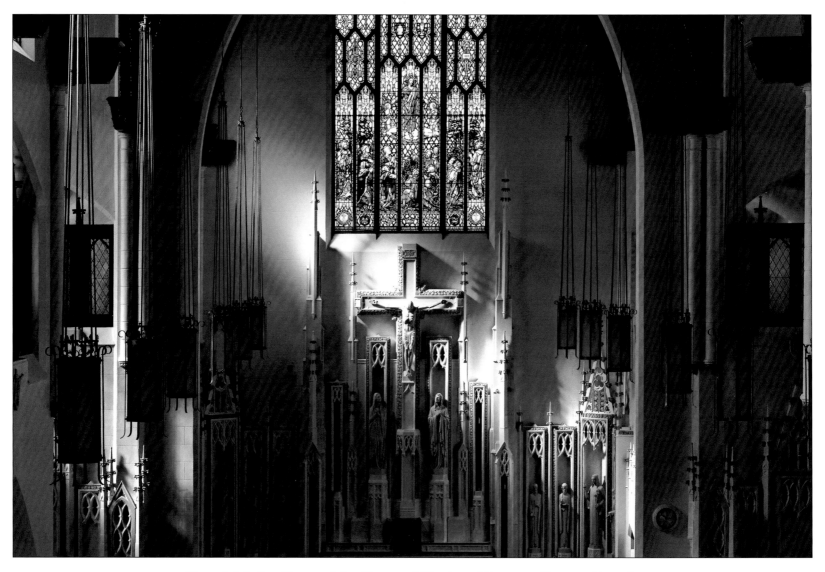

Chapel, Mother House of the Sisters of Charity of Ottawa – Ottawa, Ontario

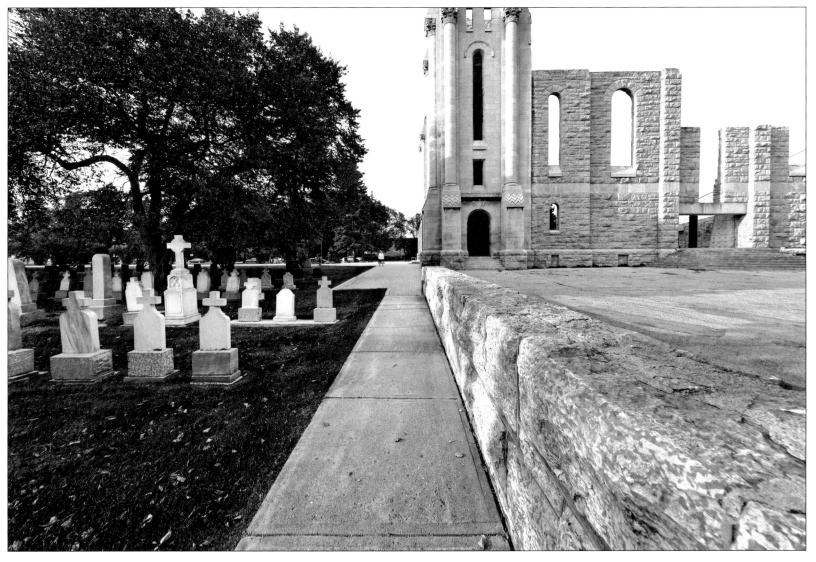

St. Boniface Cathedral – Winnipeg, Manitoba

The mission of the first church built on this site in 1818 was to convert the aboriginal population and "morally improve" delinquent Christians who had "adopted the ways of the Indians." The fifth church on the site (its walls are seen in the photograph) was the largest Roman Catholic Cathedral in western Canada. It was destroyed by fire in 1968. Louis Riel, leader of the Red River Rebellion and instigator of the North West Rebellion, is buried in the cathedral cemetery.

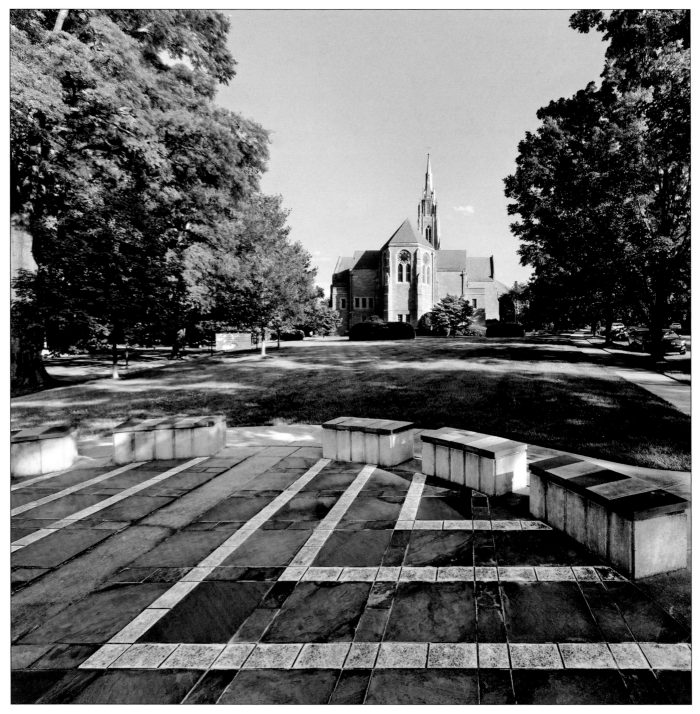

Covenant Church – Charlotte, North Carolina

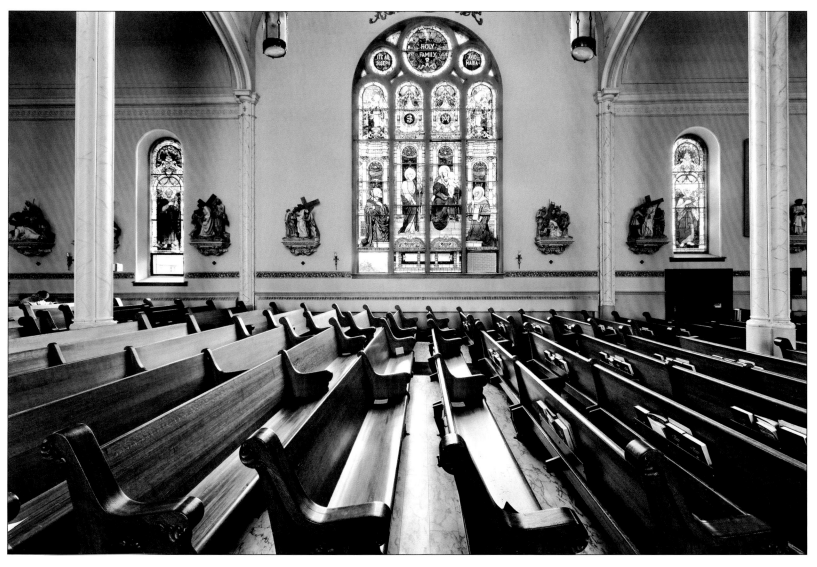

St. Mary's Cathedral – Fargo, North Dakota

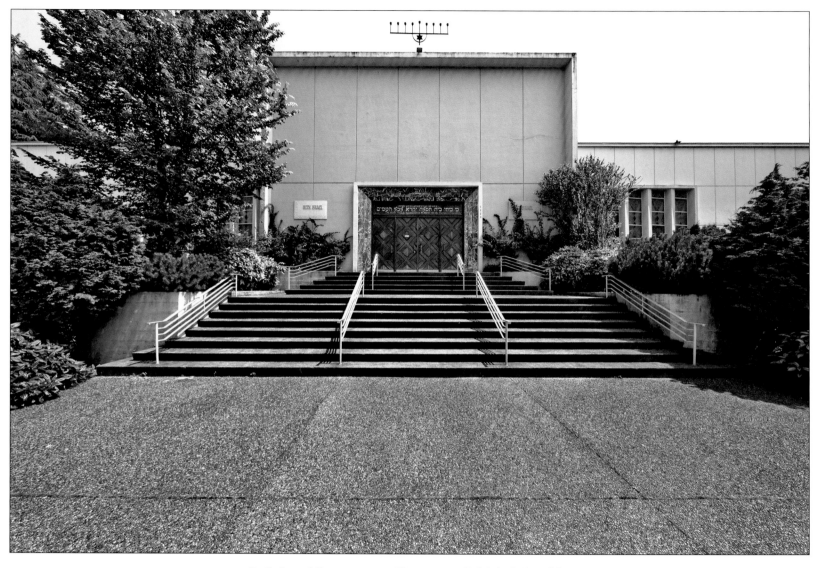

Beth Israel Synagogue – Vancouver, British Columbia

Red Deer Mosque – Red Deer, Alberta

The first meeting to establish a formal Muslim community in Red Deer in 1976 involved five families from Fiji, India, and Iran.
Until the mosque opened in 1994, prayers were held in the homes of community members or in rented halls.

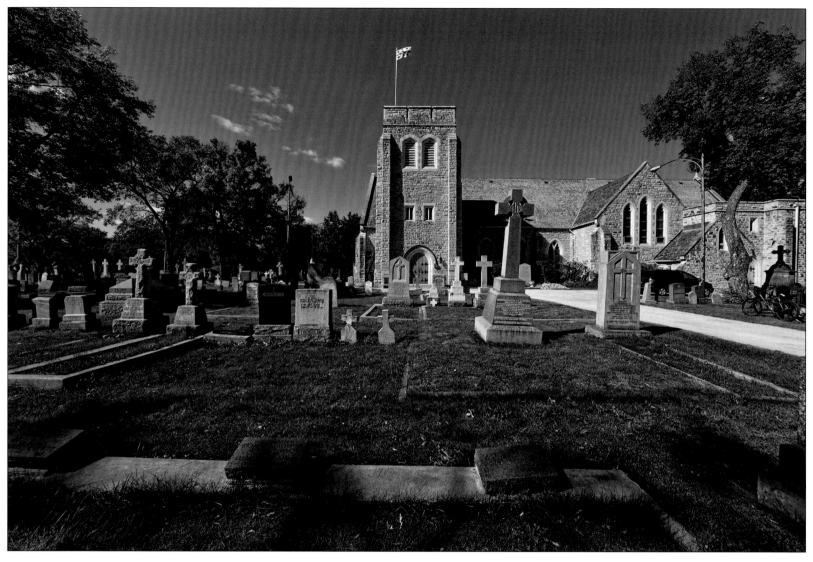

St. John's Cathedral – Winnipeg, Manitoba

The first Europeans to settle the Canadian prairies—the Selkirk settlers who came from Scotland in 1812—established a burial ground immediately south of the present Cathedral. The first Anglican priest in western Canada followed in 1820 and built a mission church nearby. That building was replaced in 1833 by what was to become the first Anglican Cathedral in what is now western Canada. The current Cathedral building—the fourth church on the site—was built in 1926.

Beth Israel Synagogue – Halifax, Nova Scotia

Former Temple Bnai Ephraim – Bismarck, North Dakota

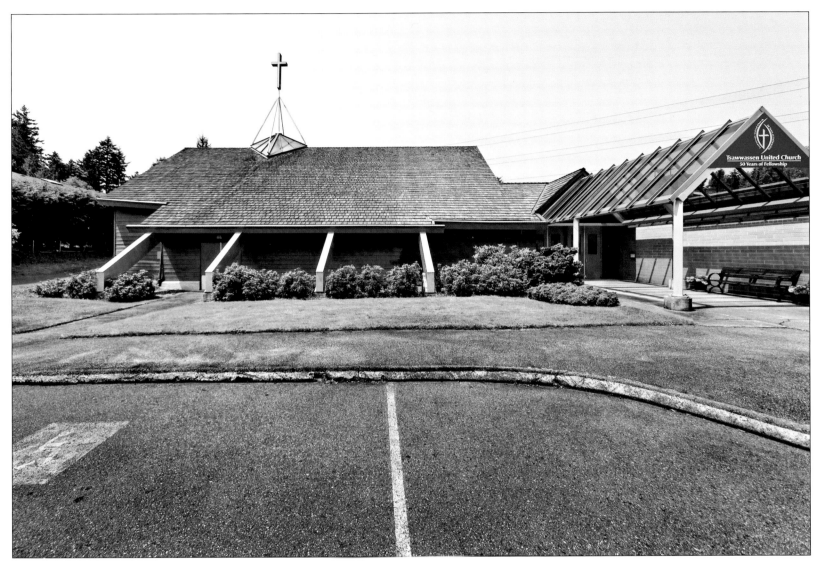

Tsawwassen United Church – Tsawwassen, British Columbia

Hai Duc Pagoda – Regina, Saskatchewan

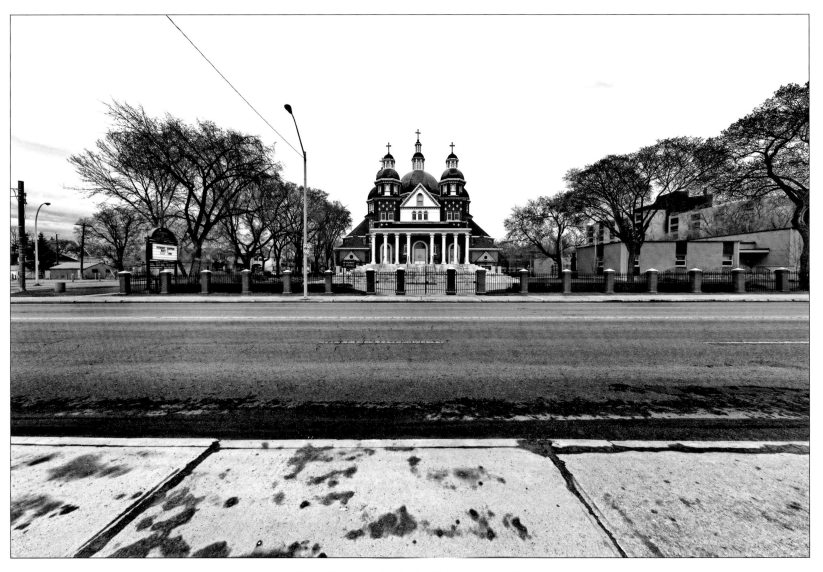

St. Josaphat's Cathedral – Edmonton, Alberta

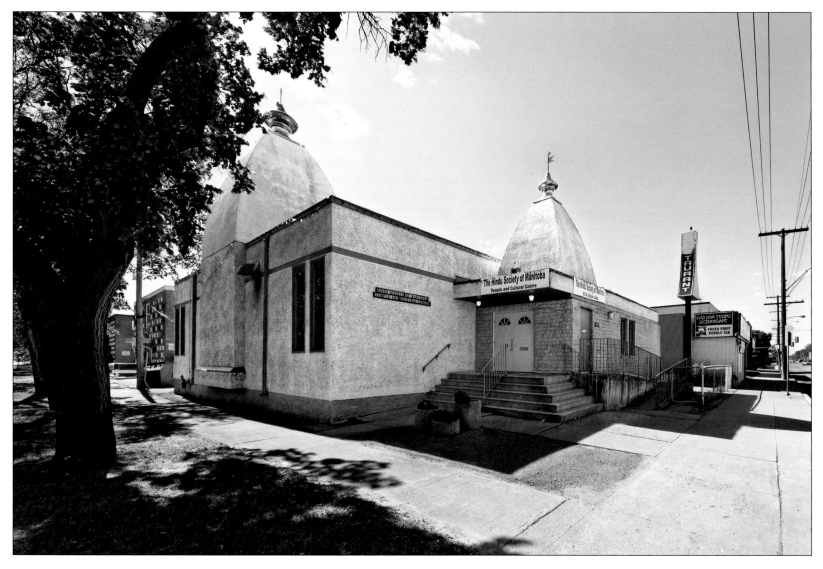

Hindu Society of Manitoba Temple – Winnipeg, Manitoba

Prof. Suwanda H. J. Sugunasiri

President, Buddhist Council of Canada

Mark Schacter:

Am I right in thinking that going to the Temple is not central to the practice of Buddhism?

Prof. Sugunasiri:

Absolutely right. Your personal liberation has nothing to do with the Temple. Buddhist principles of living help individuals whether you go to the Temple or not.

Mark Schacter:

So you would not be considered a bad Buddhist if you never went to the Temple?

Prof. Sugunasiri:

Buddhists are flexible. Buddhism does not require that you go to the Temple.

Now, of course, the community might say you are a bad Buddhist if you don't go to the Temple. They might judge you that way. But not the Buddha. The community might say

that conventionally, everyone goes, and so if you don't go, you are not part of the flock. But, in fact, I could argue that in some cases going to the Temple might not only not contribute to your liberation, but might actually be counter-liberating because not much personal practice takes place in the Temple. In the best case, when you go to the Temple you learn things that you then practice in your private life, on your own, away from the Temple. It's a personal thing—cultivating a better self. It is this practice that leads to liberation.

For some people it may not be possible to meditate at home. If they tried to do that people might laugh at them, or they would be distracted by the phone ringing or by their children, etc. In such situations, the Temple can provide these people with the only quiet place they may have for meditation.

But the ordained *sangha* members [Buddhist monks and nuns] are not between some mythical God and you. They have no hand in your liberation. They are only the teachers. Likewise the Temple has no hand in your liberation. The *sangha* can be facilitators; likewise the Temple can be a facilitating place for mind cultivation and liberation. But it is also a social place. It is used mostly as a place for people to come together for spiritual purposes in a social context.

Mark Schacter:

Please elaborate on the social importance of the Temple.

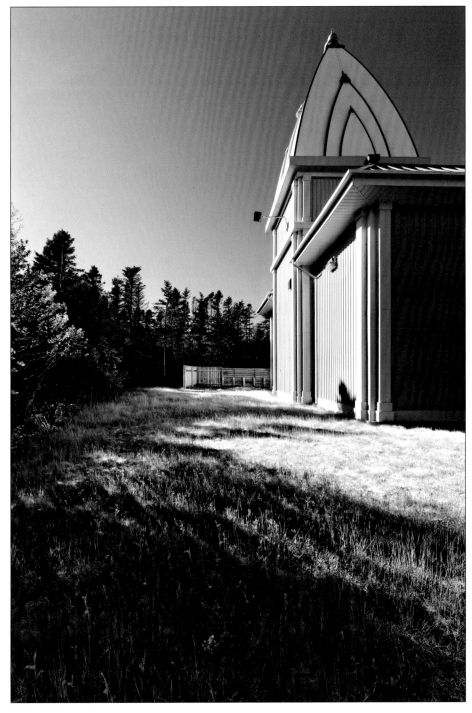

Hindu Temple – St John's, Newfoundland

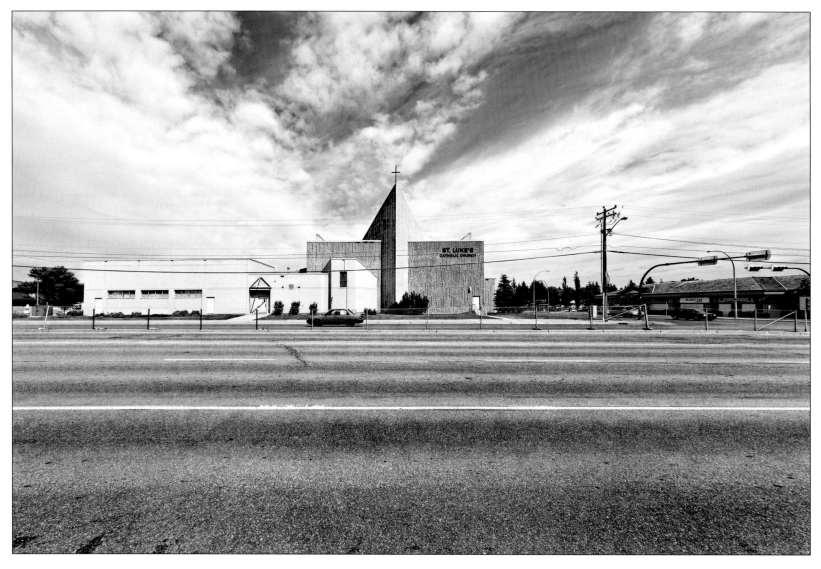

St. Luke's Church – Calgary, Alberta

Prof. Sugunasiri:

For some people it is easy to be self-reliant when it comes to meeting spiritual needs, but others find it necessary to go to a place of worship. So, even though you can be on your own as a worshipper if you have cultivated yourself, for many people this is not possible. Living takes a big toll on you. It's rare that you get the time to think about what it means to "be good." By going to the Temple, you will be reminded of what's good and bad, and of how to be good and bad. The classroom and the professor might be a good analogy. Can one learn the subject without going to classes? Of course you can. But you don't get the benefit of the insights that the professor has. In any case, at exam time, it is you alone who has to study, to write the exam and pass. The professor can't do it for you!

When you go to the Temple you have an opportunity, even for a short time, to separate yourself from the influence of "attachments" to material things that occupy the mind during daily life. The place of worship becomes an oasis to get away from attachments, and from whatever feelings of anger or hatred you may have. The house of worship provides an ambience that allows you to be a better human being, even if only for a short period of time.

And there's another element to this. The *Buddha puja* [worship service], when it is performed in the Temple, is usually led by a monk or a nun. You go through the Homage to the Buddha, sharing merits with your relatives, living and dead, chanting, and being inspired to lead a good life. And then at the end of it, the monk takes a topic from out of that worship or any other topic from the Buddhist Canon and he gives a sermon explaining it. The purpose of the sermon is to dispel ignorance, which is a barrier to liberation. So the

Salvation Army Chapel – Portage la Prairie, Manitoba

benefit that the devotee gets from the sermon is something s/he would most likely not get if s/he were worshipping on her/his own at home. Unless, that is, you can read Pali, and are a student of the Canon (also available in the living languages of Chinese and Tibetan) yourself.

The sermon often takes place in the "image house" in the Temple—the part of the Temple where you have the Buddha figure and sometimes scenes involving the Buddha and his disciples. You sit on the floor and the monk or the nun is there; he or she explains the meanings of the Buddha's teachings. The monks and nuns help people understand reality on the basis of what the Buddha taught. So the Temple becomes a centre for the study of Buddhism—a common place for people to gather and listen to what the monks or nuns have to say.

The Temple is a source of knowledge, a place for devotees to cultivate themselves, a place that allows you to forget about being bad, and perhaps, additionally, to think about being good. The house of worship is the place where all of that happens.

Mark Schacter:

The monks and nuns live in the Temple. Can you talk about the significance of this?

Prof. Sugunasiri:

The Temple has an important community dimension. Buddhist monks and nuns do not have any personal possessions or money. They depend on the community for food and shelter. Traditionally, in some countries like Sri Lanka, Burma, and Thailand, even today,

Ottawa Main Mosque – Ottawa, Ontario

Alnoor Mosque – St. John's, Newfoundland

This is the first and only mosque in the province of Newfoundland and Labrador. It opened in 1990. There are approximately two hundred Muslim families in the province.

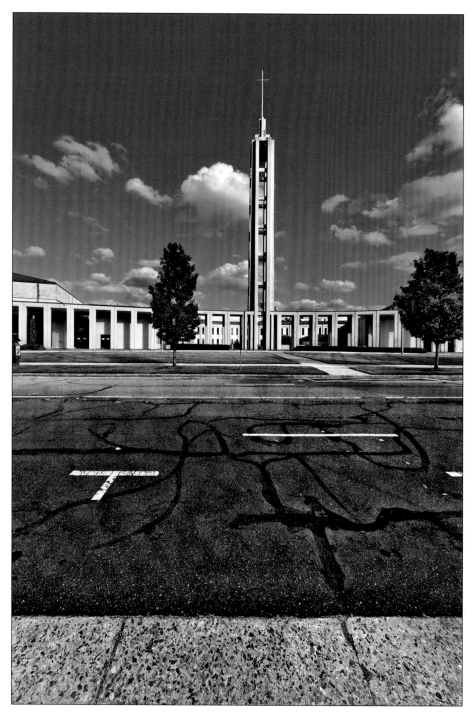

First Baptist Church – Charlotte, North Carolina

monks and nuns go on an alms round from house to house. But mostly, in a western context, they receive the food in the Temple precincts, or are invited to people's homes. Mind you, they only have the midday meal. They may have liquids after the noon hour, but no solids. In return they provide devotees with teaching. It's a way to bring together the sangha and the community in order to elevate both.

Mark Schacter:

What makes the Temple a holy place?

Prof. Sugunasiri:

A little background first. The Buddha attained something called *Arahanthood*. On the night of his enlightenment he became awakened to reality; he also became an *Arahant*, which means "worthy one," because his attachment, anger, and ignorance were dispelled. In his own time there were monks and nuns who achieved the same level of purity of mind and would therefore be assured of no rebirth, as was the case for the Buddha. But today not all *sangha* are at that level. Many are not as cultivated as that. However, they symbolize those earlier disciples of the Buddha. So when we pay homage to the *sangha* in the Temple, we also pay homage to the *sangha* of the past, present and future, as a class. So we say "I take refuge in the Buddha; I take refuge in *Dhamma* [the Buddha's teachings]; I take refuge in the *sangha*."

The *sangha* of today symbolize the purified disciples from earlier times. Therefore, that idea of purification is "in the air" in a Temple; there is a certain ambience. Since the

Mormon Temple – Calgary, Alberta

house of worship is enclosed, we can say that the ambience is captured there. To that extent the place becomes holy.

In other words, the characteristics that make a Temple holy are: 1) it is a place that encourages individuals to be better human beings; 2) there's an idea of knowledge—of self-knowledge—that is resonating in the air; 3) the Temple is home for the *sangha*, who symbolize the *Arahant*, worthy one who dispelled all personal bad qualities; and 4) there is the presence of the Buddha figure, which is the embodiment of everything perfect.

Mark Schacter:

I have seen some elaborate Buddhist Temples—very beautiful places with much ornamentation and attention to detail. How is this consistent with the Buddhist ideal of losing your "attachment" to material things?

Prof. Sugunasiri:

The answer is simple. Human beings are human beings. They have attachments. They like beautiful things. So if you want to attract someone to a Temple, what would you do? Would you have an ugly thing or a beautiful thing? You would have a beautiful thing! But once you go in, you should say to yourself, "Don't become attached to these surroundings." Just come inside and be a good human being by trying to cultivate detachment.

Cleanliness is something emphasized by the Buddha. You've been to Temples, and may have noticed how clean they are. So a temple can also be seen as an embodiment of

cleanliness, both physical and psychological.

There's another way to look at it. The Buddha says there are four types of people: those who look after themselves but not others, those who look after others but not themselves, those who look after neither themselves nor others, and, best of all, those who look after both themselves and others. Self-care and other-care.

Building a beautiful Temple is both self-care and other-care. People, who may or may not be Buddhists, who pass by the Temple will say to themselves "what a beautiful Temple!" It will make them happy. That's other-care. And for the Buddhist devotees, going into a beautiful Temple is a pleasant experience that makes them happy. This is self-care.

It's important to recognize that Buddhism has nothing against the material. Buddhists believe in the unity of mind and body. You can't have a mind without a body. If you want to look after the mind you must also look after the body. Therefore, the material world is very much a part of reality that needs to be nurtured as much as the mind.

Mark Schacter:

Thank you.

Victory Church – Moose Jaw, Saskatchewan

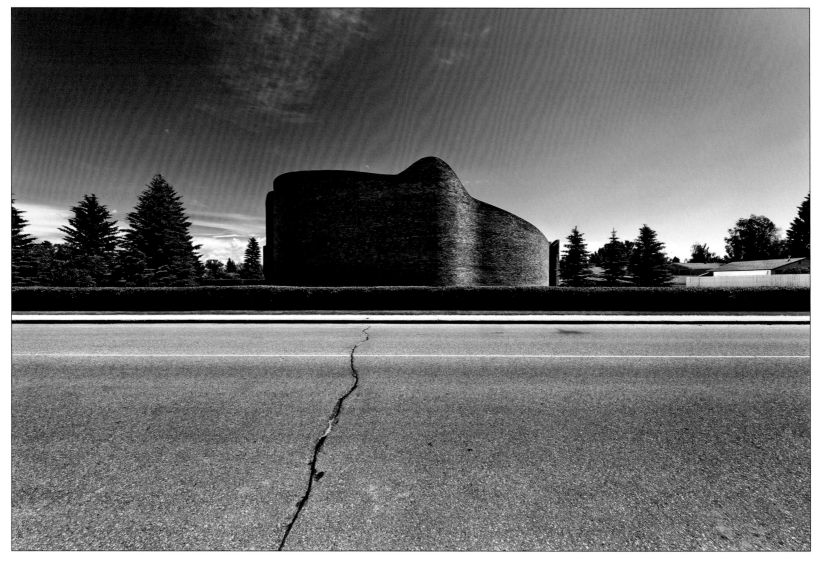

St. Mary's Church – Red Deer, Alberta

Designed by eminent Canadian architect, Douglas Cardinal, St. Mary's was featured in a 1979 Museum of Modern Art exhibition entitled Transformations in Modern Architecture. *The building incorporates the unorthodox undulating lines for which Cardinal is well known. In 1995, Cardinal unsuccessfully sued the parish to block construction of an addition designed by another architect. In an unusual argument, Cardinal contended that the addition would damage his professional reputation.*

Hopewell Independent Baptist Church – near Gowensville, South Carolina

Calgary Jamatkhana – Calgary, Alberta

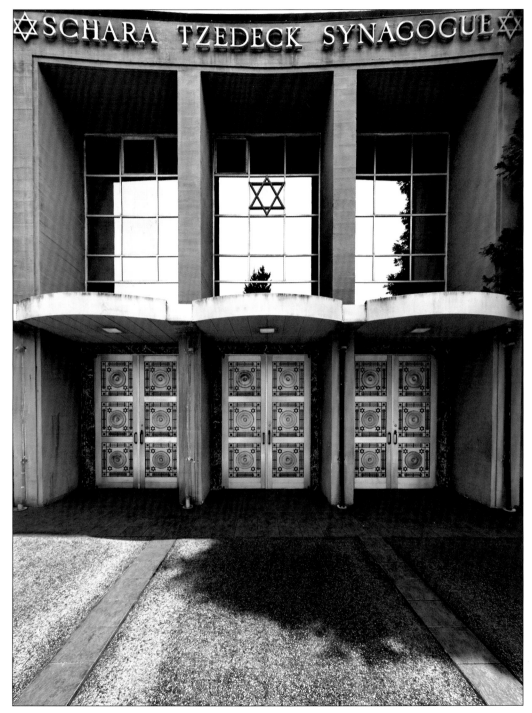

Schara Tzedeck Synagogue – Vancouver, British Columbia

St. Mary's Cathedral – Winnipeg, Manitoba

House of Jacob Synagogue – Calgary, Alberta

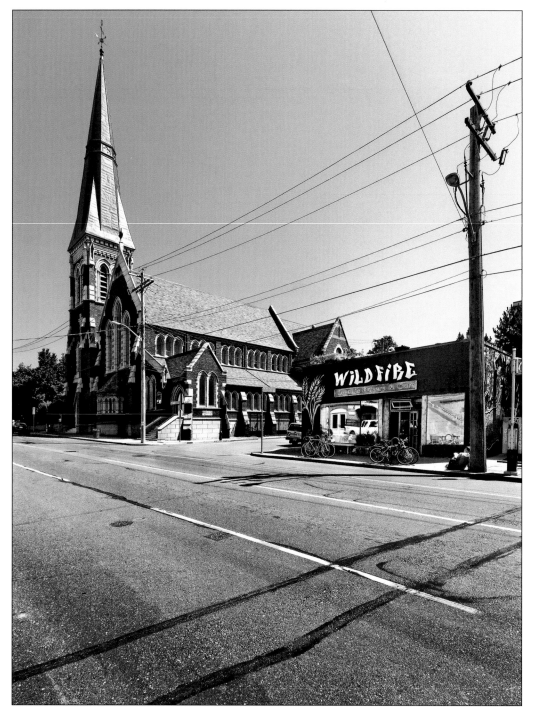

Church of St. John the Divine – Victoria, British Columbia

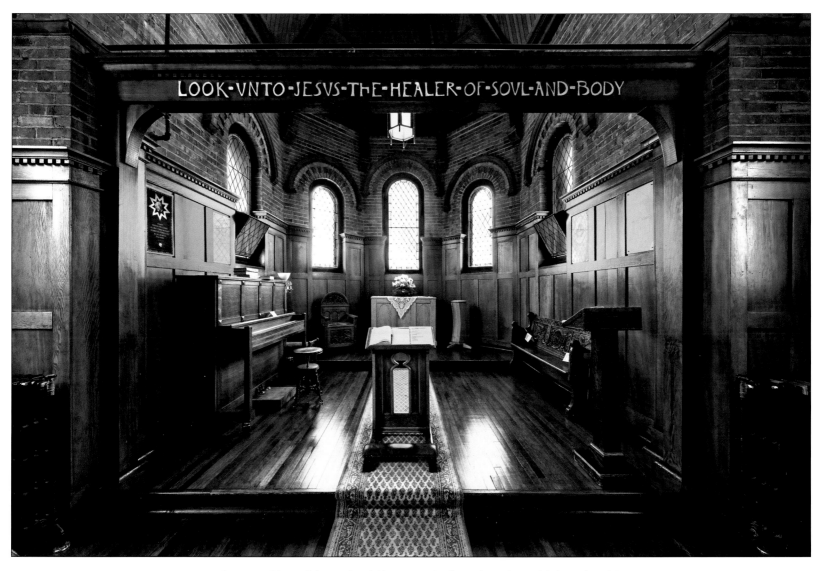

Pemberton Chapel (Royal Jubilee Hospital) – Victoria, British Columbia

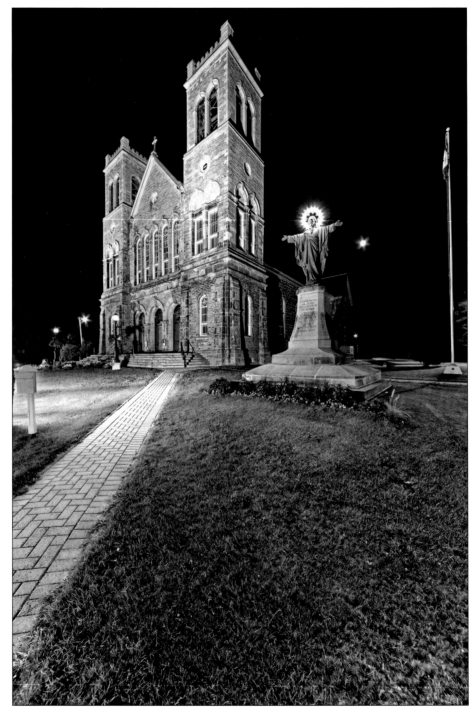

Parish Church – Ste. Agathe-des-Monts, Quebec

Mark Schacter

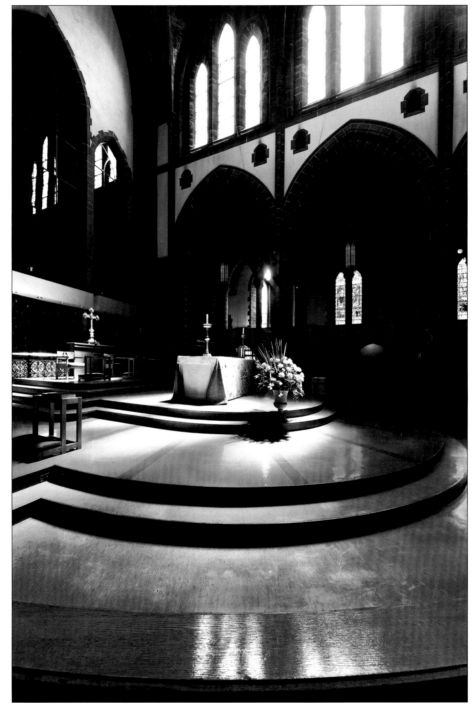

Christ Church Cathedral – Victoria, British Columbia

Soka-Gakkai International USA Las Vegas Buddhist Center – Las Vegas, Nevada

A Wedding Chapel – Las Vegas, Nevada

Las Vegas's famous wedding chapels are not houses of worship in any meaningful sense, but many of them do incorporate design elements suggestive of churches. The ease and low cost of obtaining a marriage license in Las Vegas make it a popular wedding destination. About 115,000 weddings are performed in Clark County (in which Las Vegas is located) every year—equivalent to about five percent of all weddings in the entire United States in a given year.

St. Mary's Church – Ottawa, Ontario

Mark Schacter

Pentecostal Church – Jasper, Alberta

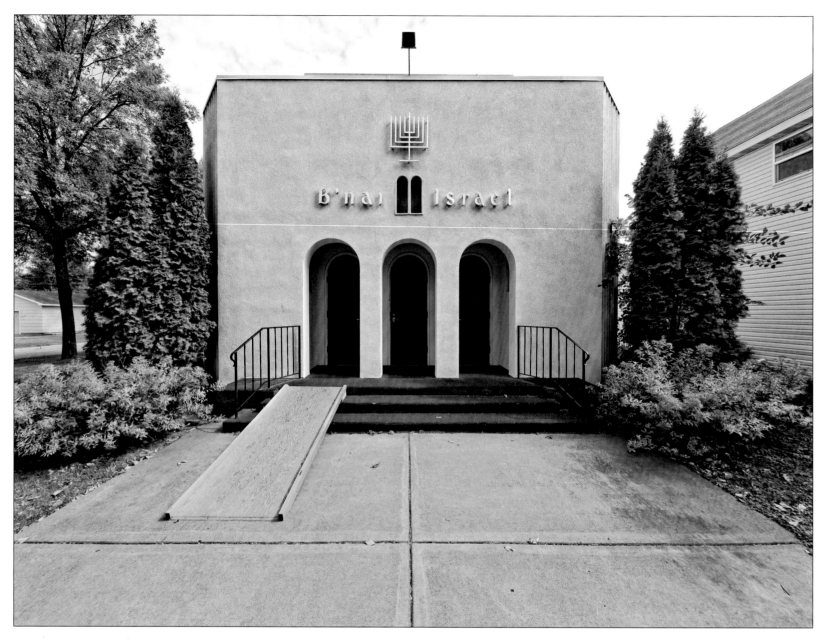

B'nai Israel Synagogue – Grand Forks, North Dakota

Mark Schacter

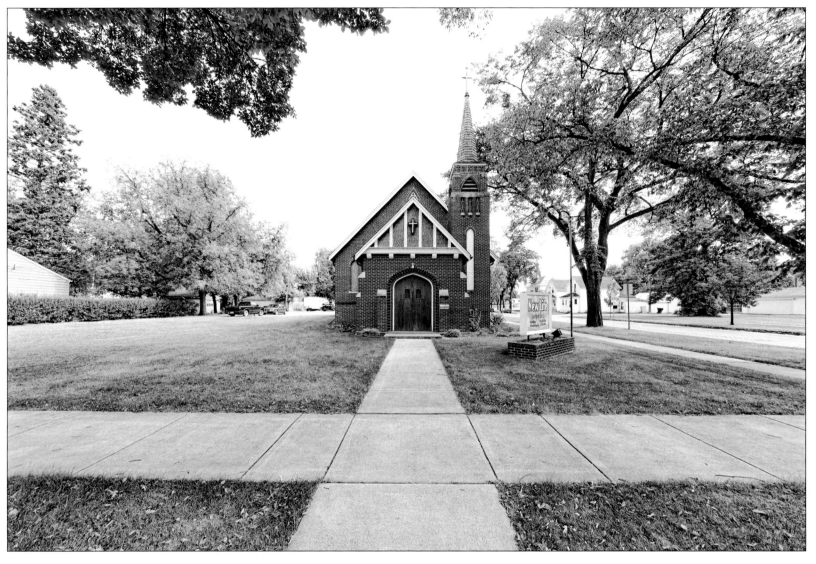

New Life Foursquare Church – Grand Forks, North Dakota

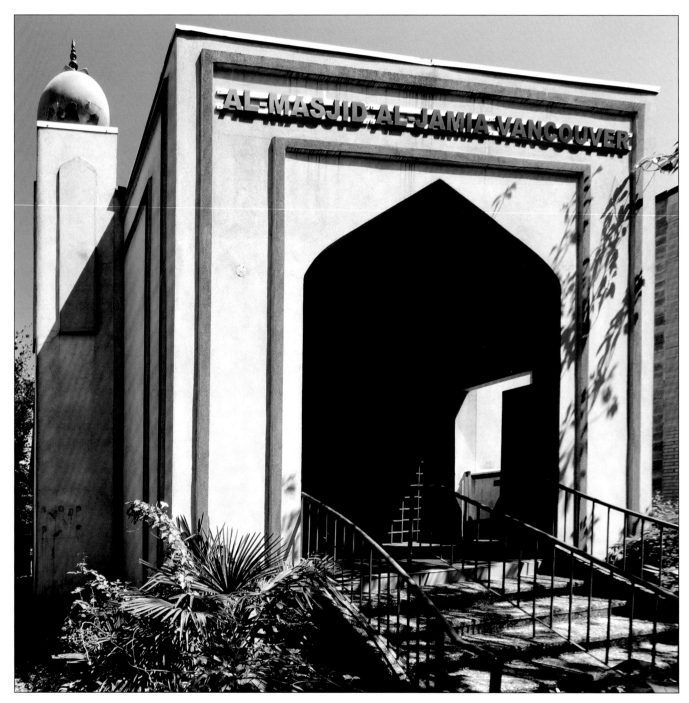

Al Jamia Mosque – Vancouver, British Columbia

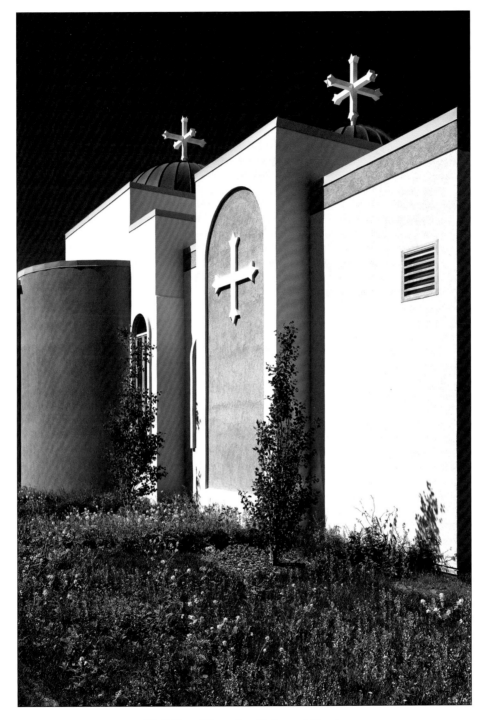

St. Mina Church – Balzac, Alberta

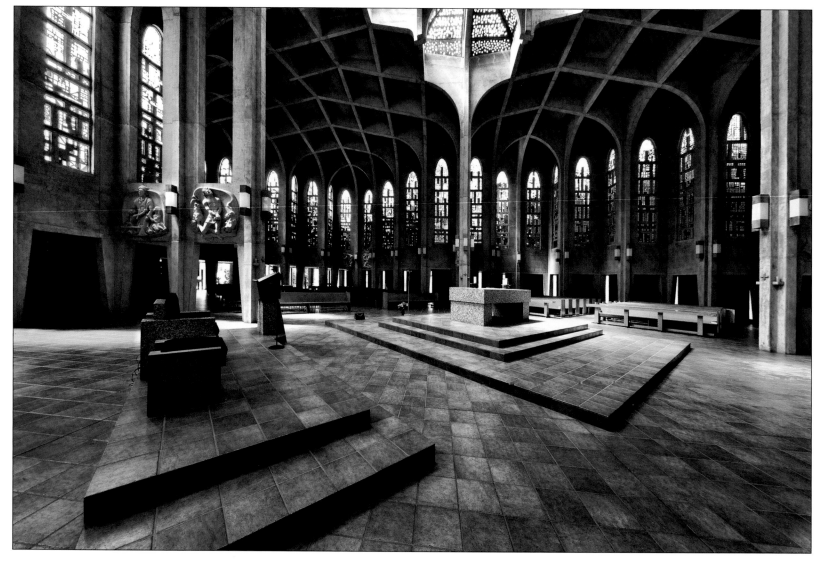

Abbey Church, Westminster Abbey – Mission, British Columbia

Westminster Abbey is home to thirty Benedictine monks. It is mostly self-sufficient, operating a farm producing meat and eggs.
The Abbey Church was completed in 1982.

Or Bamidbar Synagogue – Las Vegas, Nevada

St. John the Baptist Church – Perth, Ontario

Imam Habeeb Alli

Secretary, Canadian Council of Imams

Mark Schacter:

How important is the physical space—the house of worship—to a person's experience of faith and to his or her practice of faith?

Imam Habeeb Alli:

Historically, the concept of sacred space has been enshrined in all faiths and Islam is no exception to that.

The great edifice of the Kaaba in Mecca, the Prophet's mosque in Medina, and the Al Aqsa mosque in Jerusalem, they speak of beauty and craftsmanship, the purpose of which is to replicate a sense of deep spirituality. In fact, once the Prophet Mohammed observed someone constructing a building in Medina, and he said to that person, "Whoever builds, let him build with great pride and excellence."

There is a sense in Islam of what is called *tawheed*—the oneness of God. There is a

St. Leo the Great Church – Minot, North Dakota

Minot was a lawless frontier town when the first resident priest, Rev. F. J. McCabe, arrived in 1888. After his first sermon aimed at Minot's moral decadence, McCabe was visited by an anxious parish delegation who begged that he not scold them so severely. He promptly packed up and left. St. Leo the Great Church opened in 1908; a major restoration was completed in 2011.

sense in those architectural works of symmetry, the symmetry representing oneness. God himself says thousands of times in the Koran that He is one and unique.

Everything goes back to His unity, His mathematical single unity. In many mosques around the world there is an emphasis on symmetrical design using ceramics and blocks and concrete and colour; you also see the emphasis on symmetry in the way that the form of the arch is integrated into the design of many mosques.

And so the believer, in reciting his prayers or reciting the Koran or just secluding himself in that space, gets a sense that he is aligned with the One, that he is connecting with something that goes beyond that particular space in that particular moment.

Mark Schacter

But is it necessary for a mosque to be ornate and beautiful? Couldn't you argue that by emphasizing the appearance and material splendour of the building you are detracting from what really matters: faith and spirituality, which, after all, are not material?

Imam Habeeb Alli:

Certainly there are people who interpret spirituality as meaning that they should become austere and give up worldly things. They would rather seclude themselves in a mud hut than sit in a beautiful, expensively tiled edifice. From this perspective, any attempt at beautification would indeed be seen as luxurious and exuberant and wasteful.

This is an extreme point of view. But Islam itself speaks to a faith that is considered

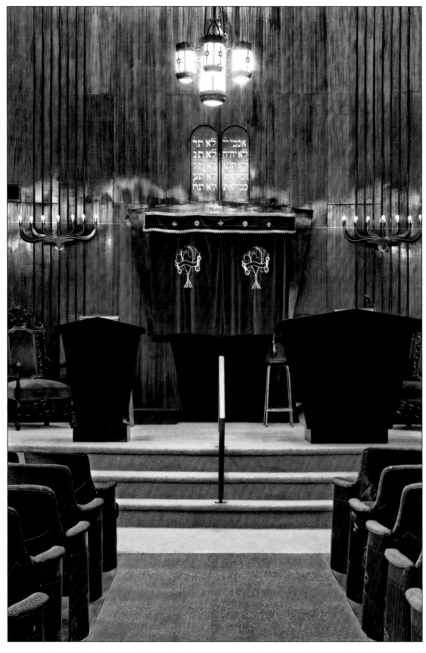

Temple Sons of Israel Synagogue – Sydney, Nova Scotia

Jews began coming to Cape Breton Island at the end of the nineteenth century. Many were fleeing religious persecution in Russia and were attracted by advertisements from coal companies offering free passage to any man willing to work in the mines. In recent times Cape Breton's Jewish population has declined sharply; Temple Sons of Israel is the last remaining synagogue on the island.

Mark Schacter

moderate. As it says in the Koran, you are considered a middle nation; you are at neither extreme.

So, while it's not expected that people should be starving while building expensive structures, on the other hand, you are not expected to have kings and paupers praying in the same mud hut. You can have ornate structures like the Kaaba in Mecca or Mohammed's mosque in Medina—and likewise in different places and for different religions all over the world, including Canada—and these buildings attract people of great spirituality: savants and saints and the pious and the righteous and the traveller. They attract both elegant world leaders and the poor. Whoever they may be, they leave the house of worship with a sense of satisfaction and spiritual elevation.

The tiles and the artistic designs in a mosque, the carpets that are soft and overflowing with gentleness—these things do not necessarily distract. Ultimately, the effect that the space has on the person is more about the person himself or herself. It's about why he or she has come to the place of worship.

So, as much as we have had our fair share in the Muslim world of simple structures and those who have taken that as the be-all and end-all, we also have beautiful edifices. It's a mark of pride that a community can have a beautiful place of worship. If you can afford it, why not have it?

Mark Schacter:

Is it the idea that a beautiful and ornate structure should transport you to a spiritual state of mind?

Imam Habeeb Alli:

It is, and it does. I have a different experience when I walk into, say, a simple mosque that is located in what used to be storefront in a shopping plaza, than I do when I enter some very beautiful and elegant space. And when I am in one of those beautiful places I experience that spiritual elevation, and I feel that there is a certain sense of softness and gentleness and calm and grace, as if I am surrounded by the very same grace that heaven has promised to believers. And so I feel grateful for that.

Mark Schacter:

There are many small communities where there are Muslims but no mosque. How important is it to the practice and the experience of the faith and to feeling part of a community of worshippers to actually have the building rather than, perhaps, saying your prayers with a group of people in your home?

Imam Habeeb Alli:

The Prophet Mohammed, when he started out, purchased some land from two orphans and built thatched-roof mud huts in a few days. But, as abundance came to that growing community, the mosque became more of a bricks-and-mortar structure, and eventually evolved into the very large and beautiful structure that we see in Medina today.

As a community grows, it is expected to spend more upon its place of worship that its members love so much, as a manifestation of the bounty that God has blessed it with.

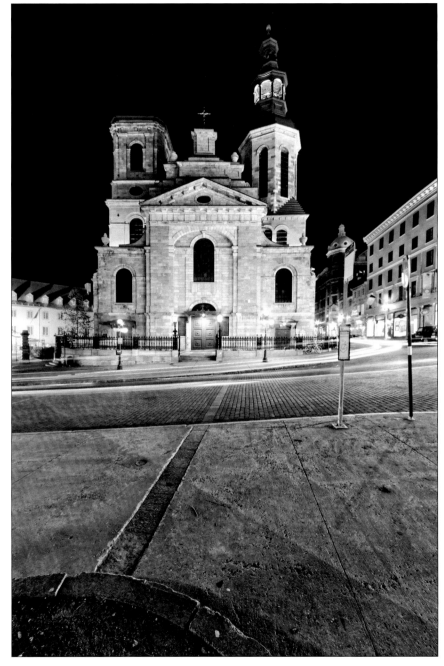

Basilica-Cathedral Notre Dame de Quebec – Quebec City, Quebec

This was the first Catholic Cathedral in what was to become Canada and the United States. Built in 1647, it was destroyed by the British during the siege of Quebec in 1759, rebuilt between 1766 and 1771, heavily damaged by fire in 1922, and rebuilt again.

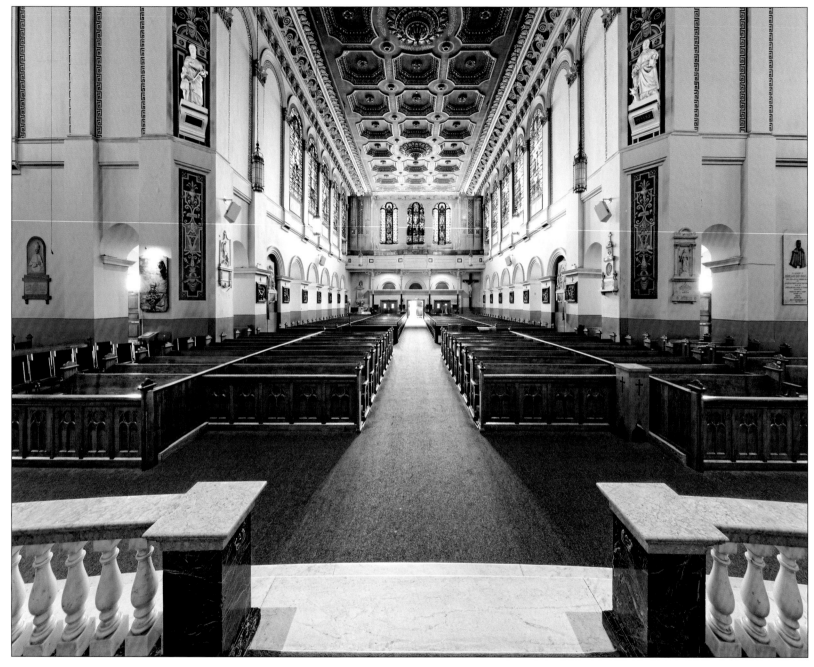

Basilica of St. John the Baptist – St. John's, Newfoundland

At the time of its completion in 1855, the Basilica was the largest church building in North America. It was one of the few buildings in St. John's to survive the Great Fire of 1892 that destroyed most of the city's east end.

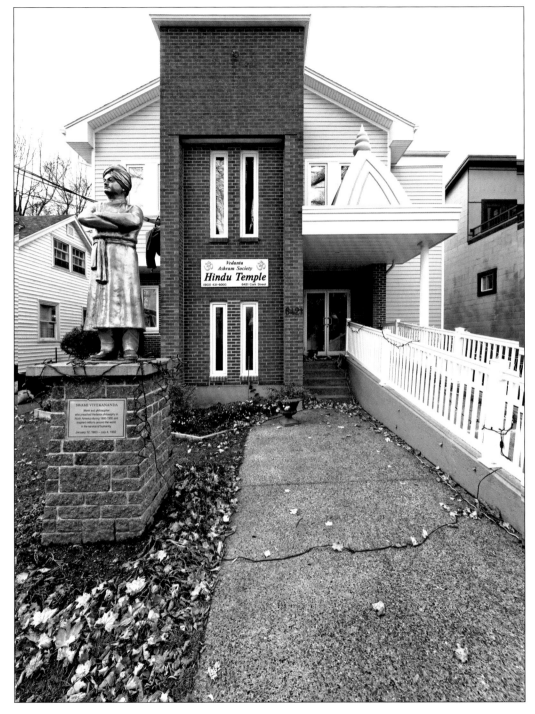

Vedanta Ashram Society Hindu Temple – Halifax, Nova Scotia

It is not expected, however, that any community should go into debt, or draw from the donations that are needed for the poor, or even from the general fund that was created for the mosque itself for the purpose of decoration. The general rule of thumb is that decorations are only to be done when personal donations are made.

But everyone in the community benefits from that aesthetic improvement and the enhancement it gives to spiritual experience. This can be especially true for people who are accustomed to luxurious decoration in their own homes. Coming into a special space that has these beautiful features sometimes helps to draw these people quickly into a spiritual realm and pull them away from that temporal, material world even for a short time.

Mark Schacter:

Is there anything you would like to add?

Imam Habeeb Alli:

There are communities that are struggling to build their own places of worship, and yes, we are all part of the larger community effort to help each other. Sometimes we feel that more selflessness from established communities would definitely be warranted to help those who are still in the process of building.

However, we would not want to criticise those communities that choose to express their spirituality through beautiful architecture; I will always support such beautiful

Shaar Shalom Synagogue – Halifax, Nova Scotia

architecture as a symbol of the fact that God is beautiful and He loves beauty.

Mark Schacter:

Thank you.

St. Theresa's Church – Halifax, Nova Scotia

Etz Chayim Synagogue – Winnipeg, Manitoba

Gates of Zion Centre – Thornhill, Ontario

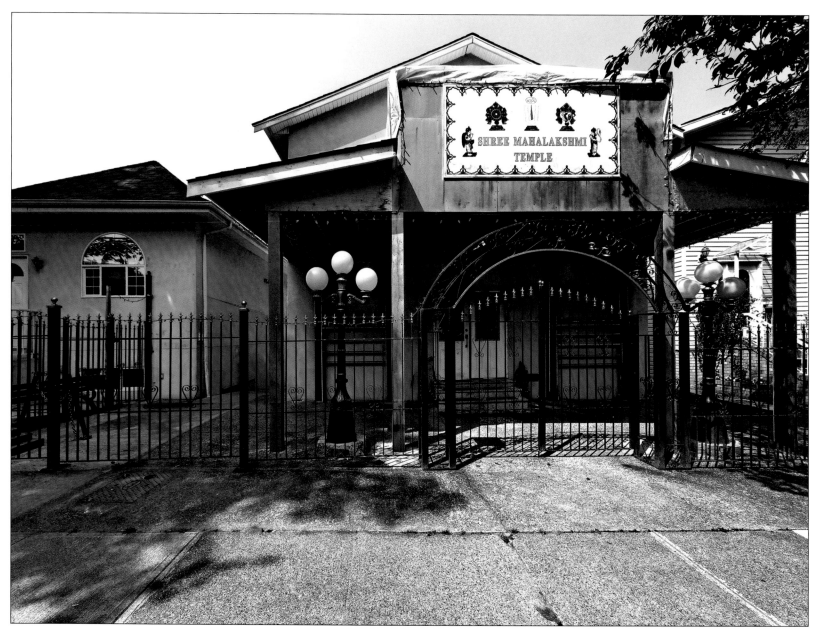

Shree Mahalakshmi Temple – Vancouver, British Columbia

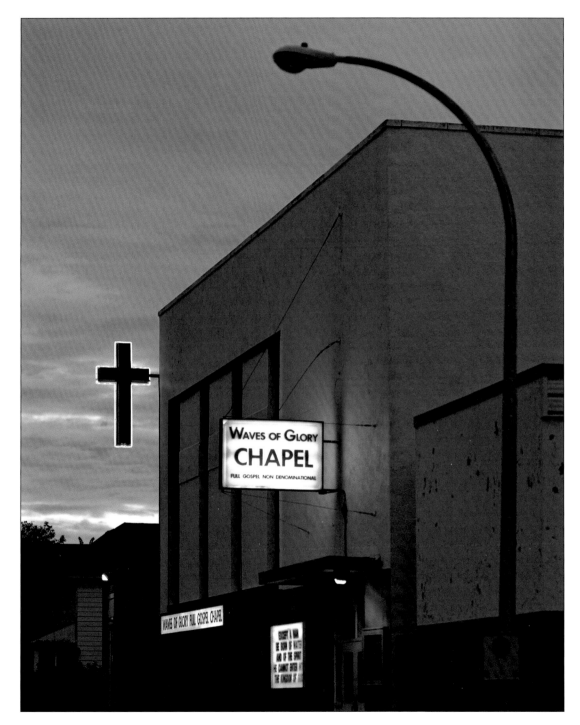

Waves of Glory Chapel – Winnipeg, Manitoba

St. Luke's Church – Winterton, Newfoundland

St. Joseph's Oratory – Montreal, Quebec

Abandoned Church – near Bruno, Saskatchewan

Nanaksar Gurdwara Gursikh – Richmond, British Columbia

Holy Trinity Cathedral – Vancouver, British Columbia

Holy Blossom Temple – Toronto, Ontario

Home to the oldest Jewish congregation in Toronto, the Temple dates to 1856 when seventeen members of the then-small Toronto Jewish community met to form a congregation and make plans for the upcoming High Holy Days. Holy Blossom now has more than seven thousand members.

St. Mary's Cathedral Basilica – Halifax, Nova Scotia

Construction of what was to become Canada's second Catholic Cathedral (the first was Notre Dame de Quebec in Quebec City) began in 1820. No local craftsman had ever worked on a roof of comparable size, so shipwrights were hired to build the roof as they would the hull of a ship.

Cathedral of the Immaculate Conception – St. John, New Brunswick

St. Dunstan's Basilica – Charlottetown, Prince Edward Island

Timothy Eaton Memorial Church – Toronto, Ontario

In 1869 Timothy Eaton founded the department store chain that bore his name, and that went on to be a dominant force in Canadian retailing before its bankruptcy in 1999. The Church, completed in 1914, was built on land donated by Eaton's widow and son. The First World War flying ace Billy Bishop—Canada's best-known war hero—married Eaton's granddaughter in this church in 1917.

Central United Church – Calgary, Alberta

Mark Schacter

Holy Trinity Metropolitan Cathedral – Winnipeg, Manitoba

Hilda Jayewardenaramaya Buddhist Temple – Ottawa, Ontario

St. Jean Baptiste Church – Morinville, Alberta

Morinville is an island of French-Canadian culture and history in the broad prairie of central Alberta. Father Jean-Baptiste Morin led several francophone families to the Morinville area from Quebec in 1891 as part of a plan to encourage francophone settlement in western Canada. The church opened in 1908. Its ornate ecclesiastical style is a reflection of its French-Canadian roots.

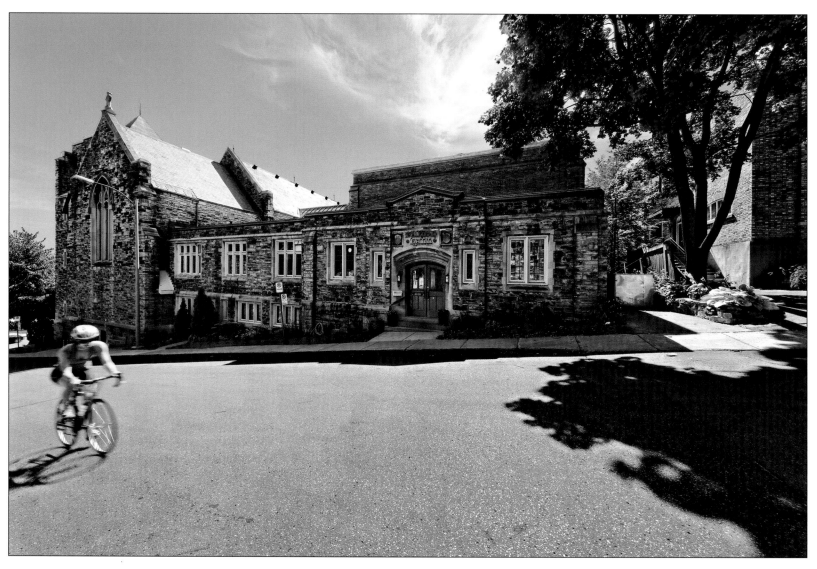

St. Matthias' Church – Montreal, Quebec

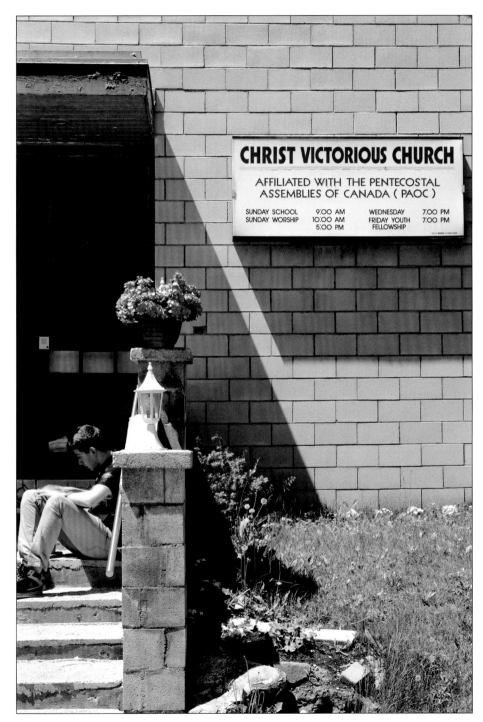

Christ Victorious Church – Montreal, Quebec

Sikh Temple – Mission, British Columbia

All Saints Cathedral – Quebec City, Quebec

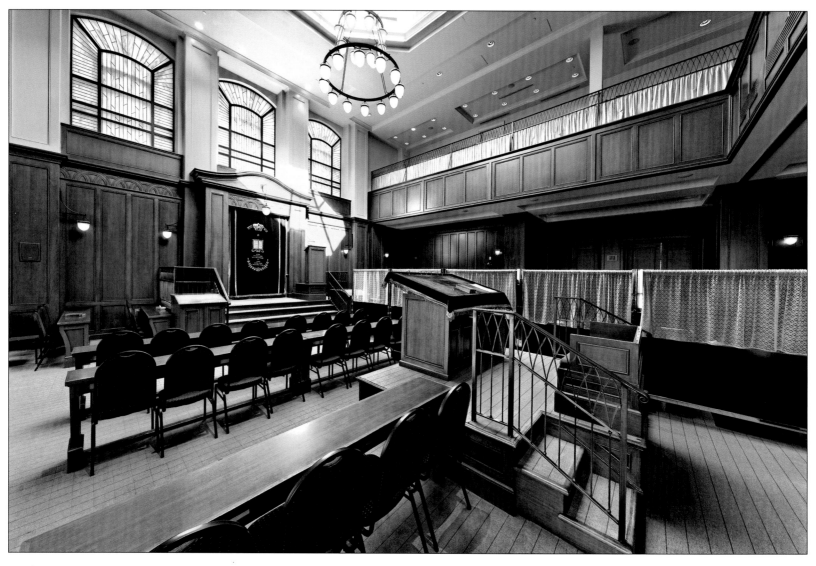

Montreal Torah Center - Bais Menachem Chabad Lubavitch – Montreal, Quebec

Sacré Coeur Church – Bourget, Ontario

St. Joseph's Basilica – Edmonton, Alberta

Holy Rosary Cathedral – Vancouver, British Columbia

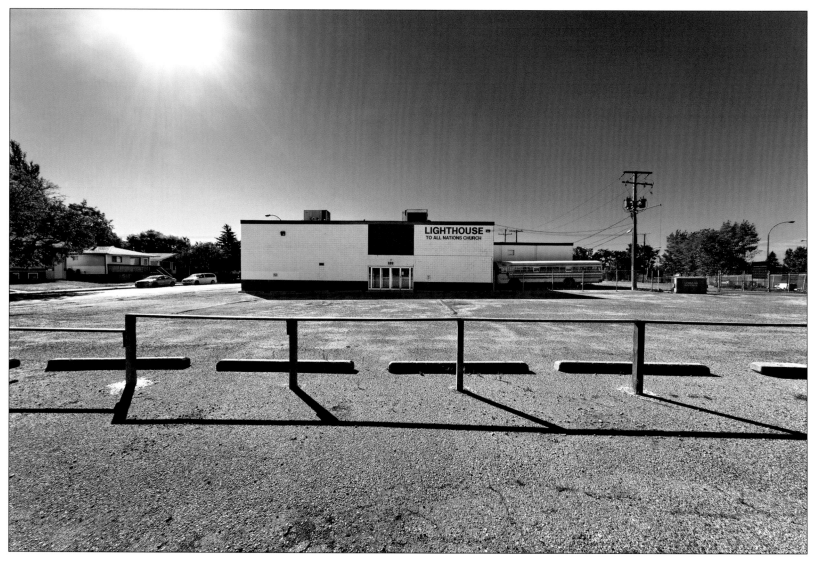

Lighthouse to All Nations Church – Regina, Saskatchewan

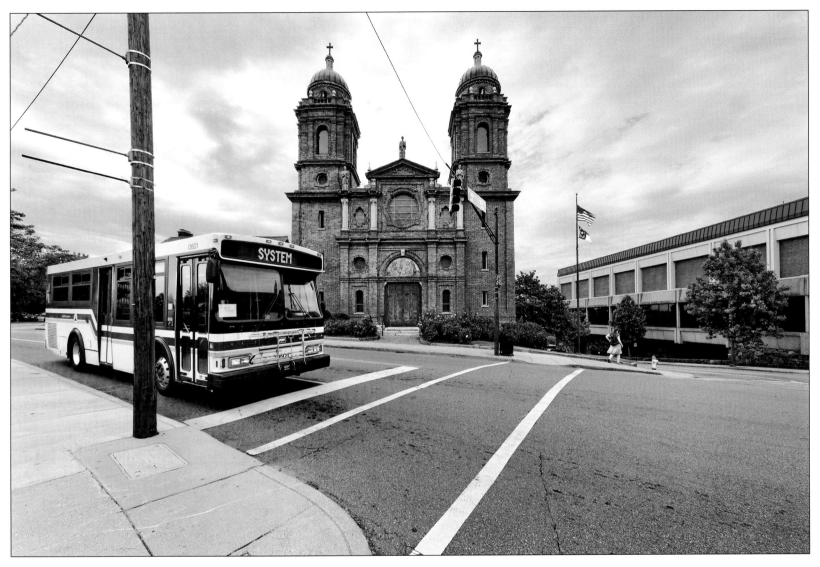

St. Lawrence Basilica – Asheville, North Carolina

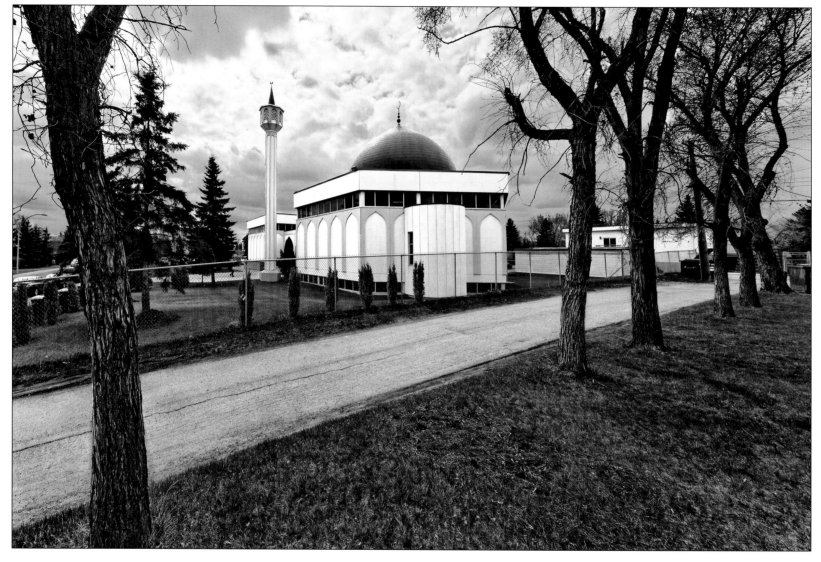

Al Rashid Mosque – Edmonton, Alberta

The original Al Rashid Mosque—the first mosque built in North America—opened in 1938. No one in the local building industry had ever seen a mosque, let alone built one. Not surprisingly, the original mosque ended up looking like something Albertan builders would have been much more familiar with: a Russian Orthodox Church! As the Edmonton-area Muslim community expanded (today it numbers approximately thirty thousand) it outgrew the old structure. The new Al Rashid Mosque (pictured) opened in 1982.

Trinity Church – Toronto, Ontario

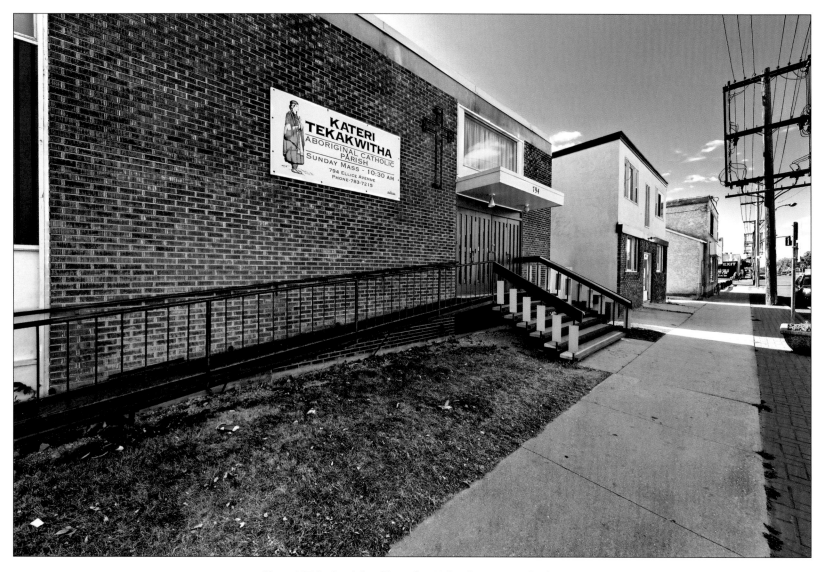

Kateri Tekakwitha Church – Winnipeg, Manitoba

Kateri Tekakwitha, an Algonquin-Mohawk woman born in 1856 in Auriesville, New York, became North America's first aboriginal Catholic saint in 2012. The miracle accepted as the basis for her canonization was the healing of a twelve-year-old boy diagnosed with a terminal case of flesh-eating disease. The boy's infection began to dissipate after family members placed a relic of St. Kateri on his leg.

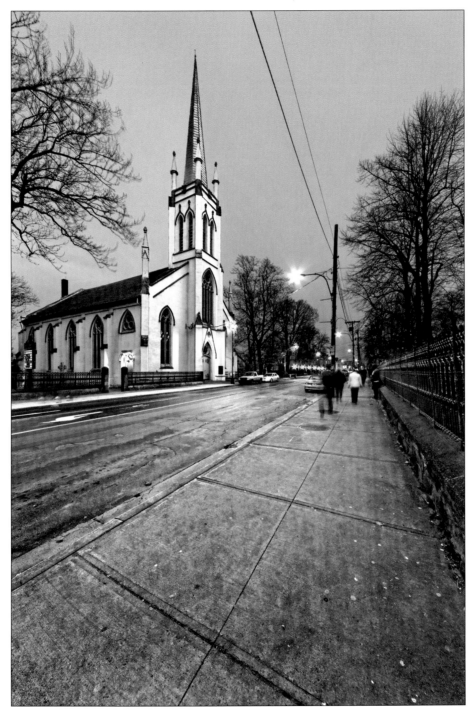

St. Matthews Church – Halifax, Nova Scotia

Madinah Mosque – Toronto, Ontario

Now one of the largest mosques in Toronto, the Madinah Mosque first operated out of a rented basement as a prayer hall. The current building was purchased from the Church of Scientology in 1983. The mosque was founded by Sunni Muslims from Gujarat, India.

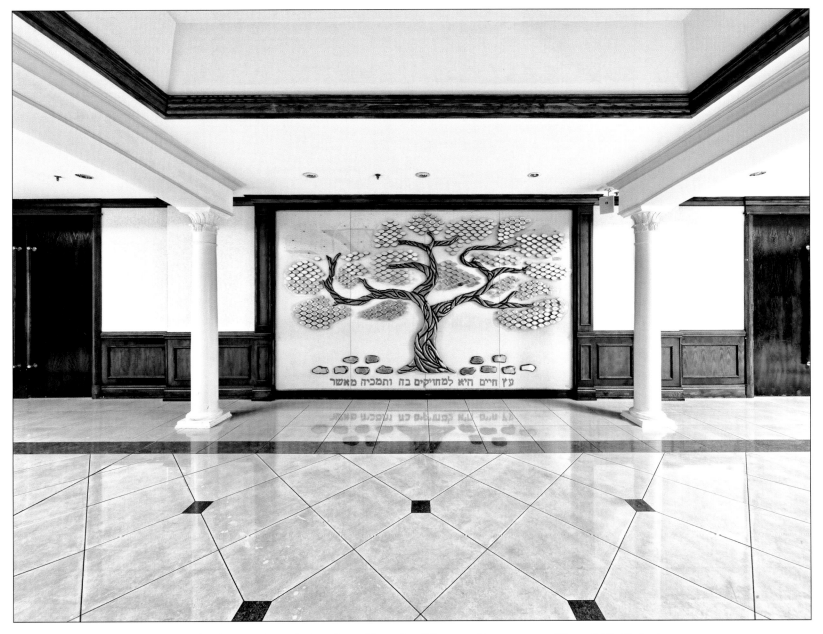

Tree of Life Mural, Beth Avraham Yoseph of Toronto Synagogue – Thornhill, Ontario

The mural in the synagogue's entrance foyer depicts, in Hebrew script along the bottom, the opening phrase of a passage in the Book of Proverbs that describes the Torah (the first five books of the Hebrew bible) as "a tree of life to all who grasp it, and whoever holds on to it is happy; its ways are ways of pleasantness, and all its paths are peace."

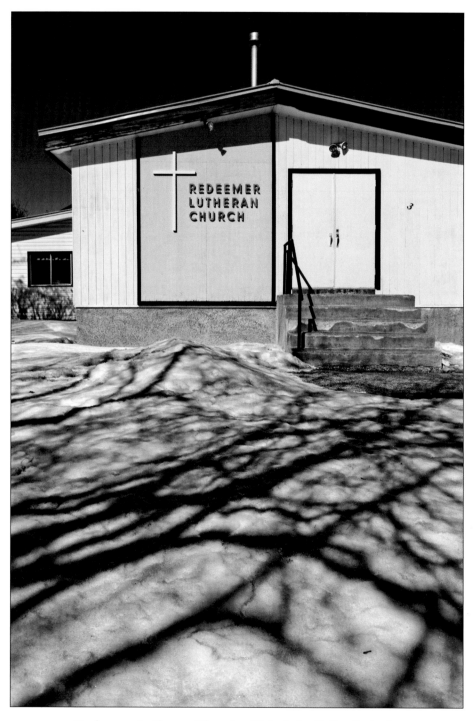

Redeemer Lutheran Church – Kakabeka Falls, Ontario

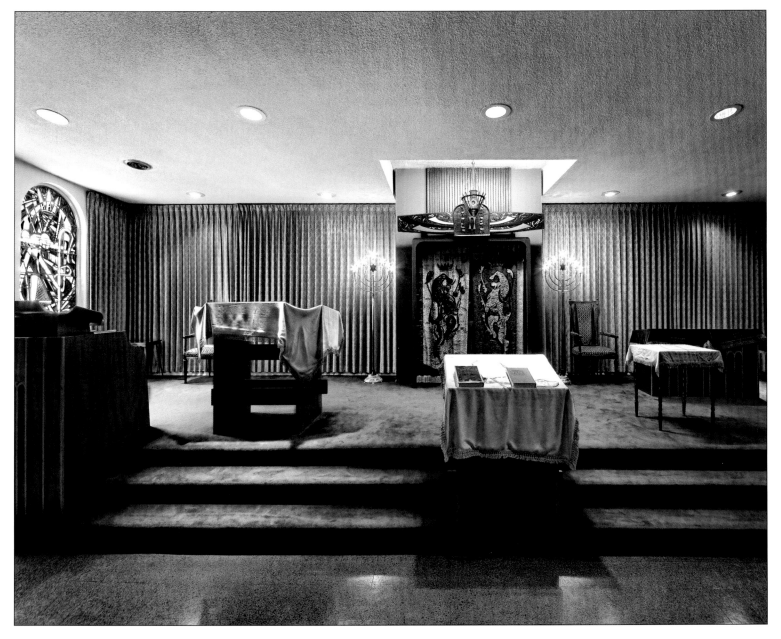

Shaarey Shomayim Synagogue – Thunder Bay, Ontario

What is now Thunder Bay was a remote frontier outpost when Jews first arrived in the mid-1800s. They began coming in larger numbers at the turn of the century, attracted by cheap land and fleeing oppression and discrimination in Russia and Poland. One immigrant was Max Laskin from Riga, Latvia, who deserted the tsarist army in 1905 to avoid service in the Russo-Japanese War. His son Bora became the first Jew to serve on the Supreme Court of Canada and was appointed Chief Justice in 1973. The Shaarey Shomayim congregation was founded in 1908.

Corpus Christi Church – Thunder Bay, Ontario

Dar as Salaam Mosque – Charlottetown, Prince Edward Island

Opened in 2012, this was the first permanent mosque for the approximately one hundred Muslim families of Prince Edward Island. In its short life it has already felt the threat of anti-Muslim intolerance. In the fall of 2012, people going to dawn prayers found a bottle on the mosque's doorstep that they said contained gasoline, as well as posters saying "Defeat jihad."

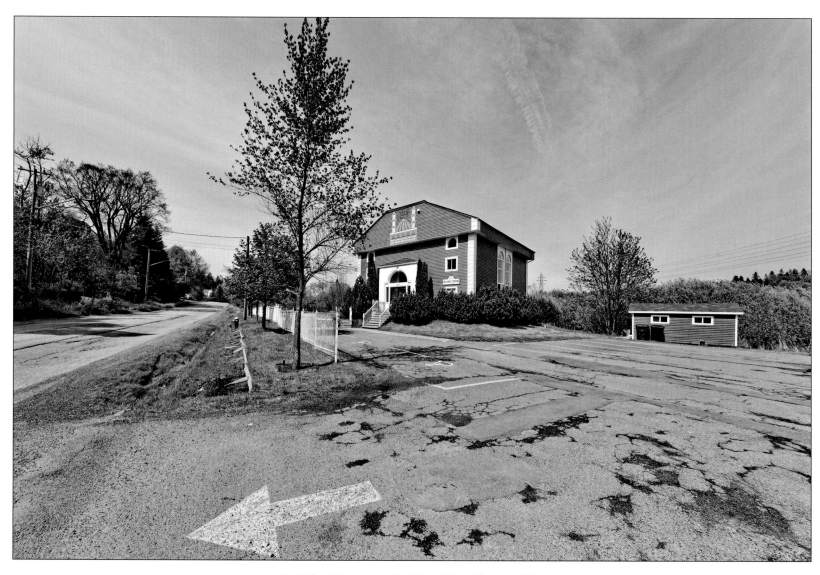

St. John Mosque – St. John, New Brunswick

Sikh Temple – Regina, Saskatchewan

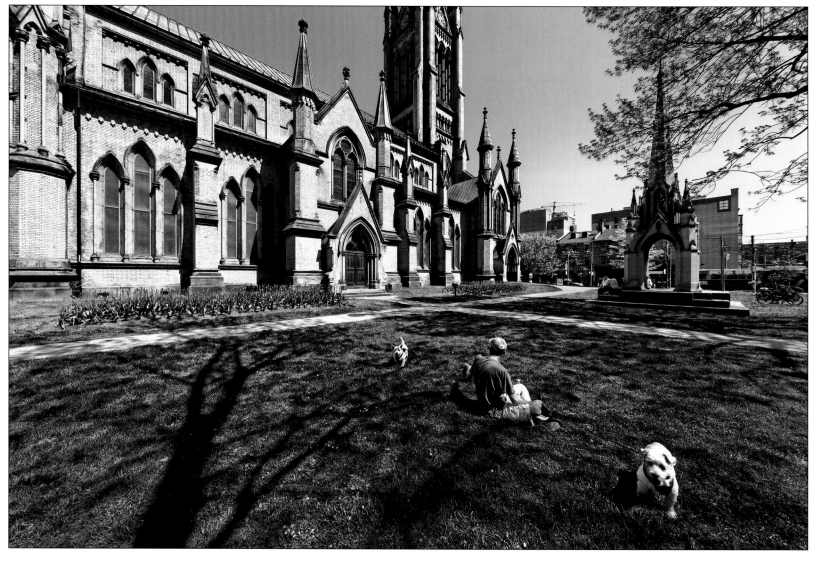

Cathedral Church of St. James – Toronto, Ontario

The first church on this site was a wooden structure built in 1807. Used as a hospital during the War of 1812, it was looted by American troops. The original chapel was replaced by a stone building in 1833, which was destroyed by fire in 1849. The current Cathedral opened in 1853. The bell tower contains a full set of twelve change-ringing bells, one of only two such installations in North America. The tower itself, rising ninety-three metres above the street, is one of the tallest church bell towers in the world.

Beth Israel Ohev Sholem Synagogue – Quebec City, Quebec

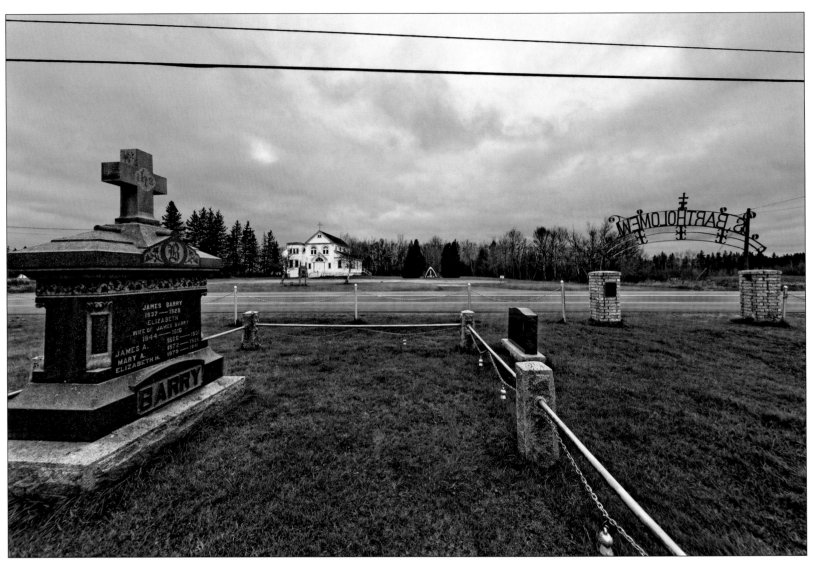

St. Bartholomew's Church – near Cape Tormentine, New Brunswick

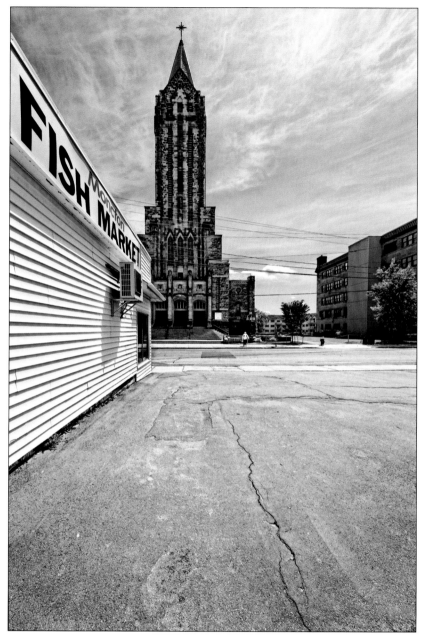

Our Lady of the Assumption Cathedral – Moncton, New Brunswick

Both an architectural monument and a monument to the faith and history of the French-speaking Acadian people of eastern Canada, the seventy-three-year-old Cathedral now faces an uncertain future. The building requires $7 million of repair work—a sum that the Diocese of Moncton has been unable to raise. While the Cathedral once served a thousand families, that number has now dwindled to about three hundred.

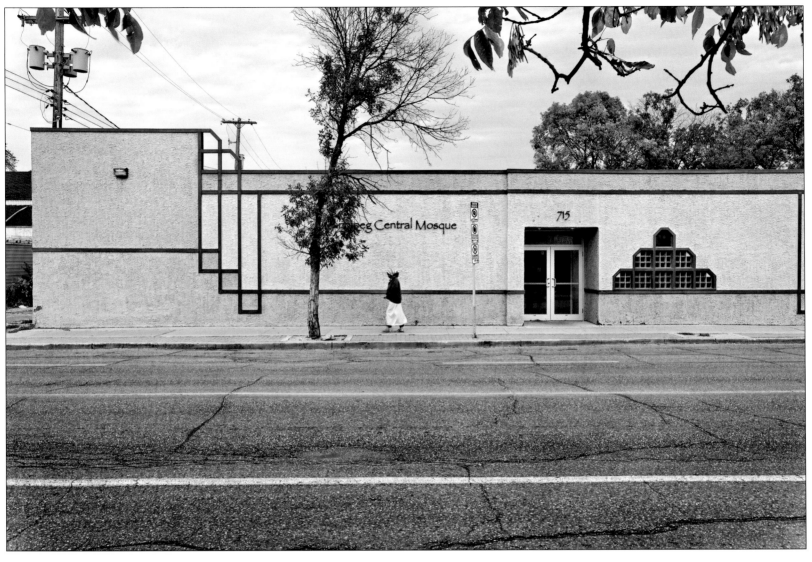

Winnipeg Central Mosque – Winnipeg, Manitoba

Church of the Redeemer – Winnipeg, Manitoba

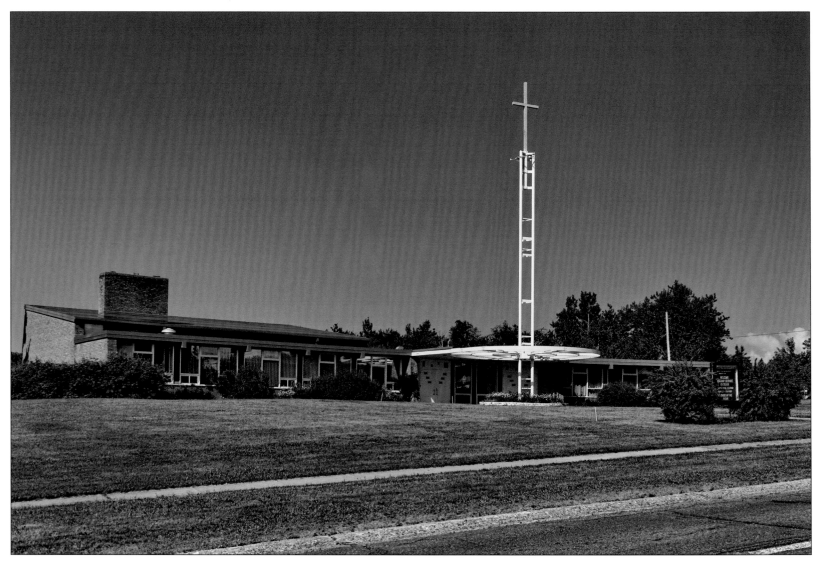

United Protestant Church – Silver Bay, Minnesota

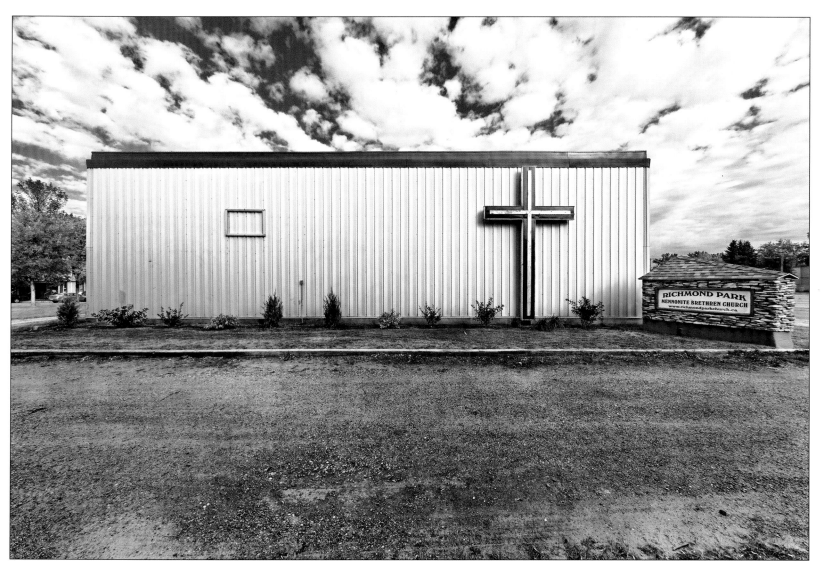

Richmond Park Mennonite Brethren Church – Brandon, Manitoba

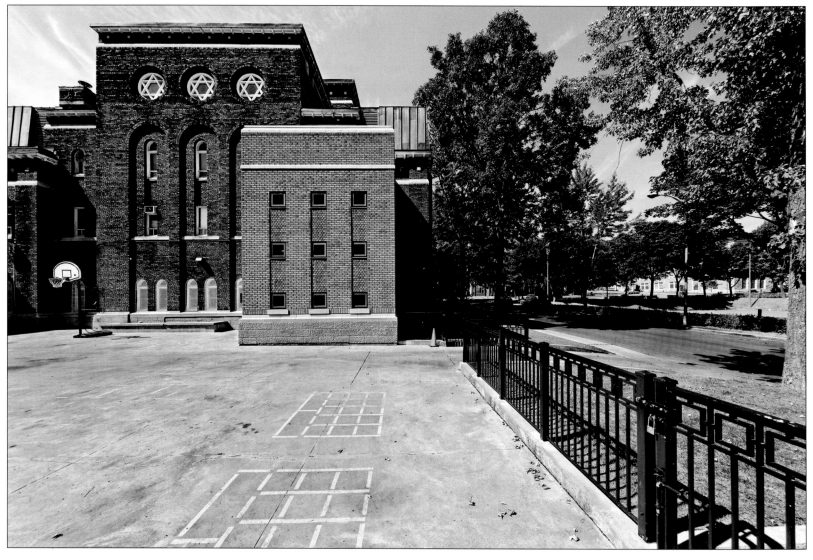

Shaar Hashomayim Synagogue – Montreal, Quebec

Jewish settlement in Quebec began in 1760, and Canada's first Jewish congregation was established in Montreal in 1768. A group of English, German, and Polish Jews founded the Shaar Hashomayim congregation in 1846. At the time there were less than two hundred Jews in Montreal—the city's current Jewish population is about ninety-five thousand. Services were first held in a rented room. The congregation moved several times. The current Shaar Hashomayim Synagogue opened in 1922.

Toronto Buddhist Church – Toronto, Ontario

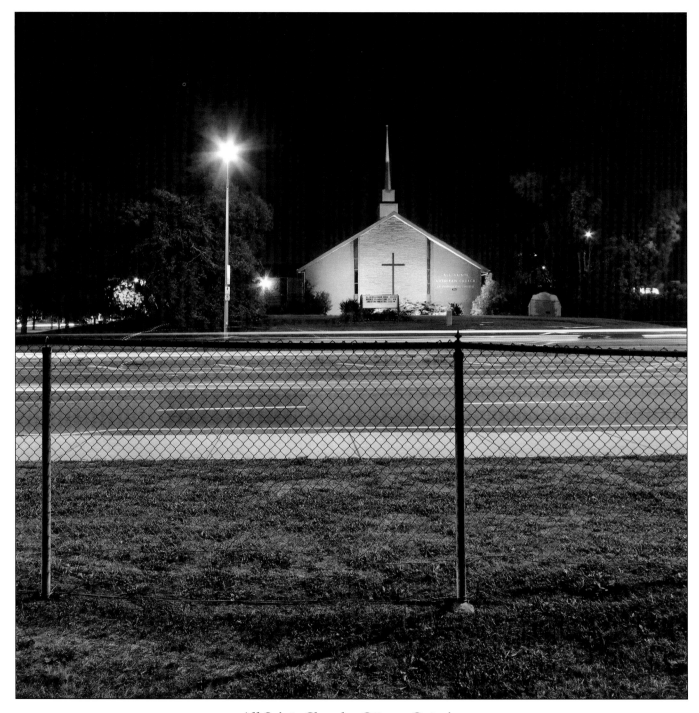

All Saints Church – Ottawa, Ontario

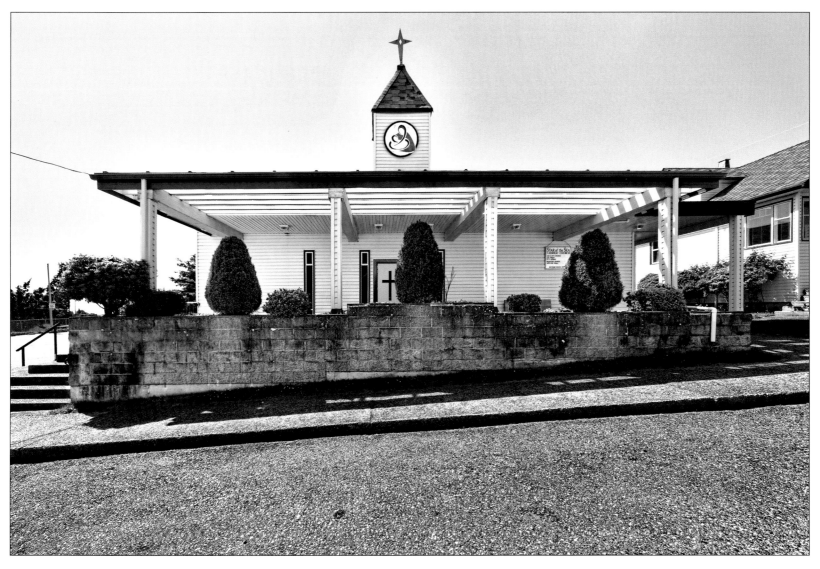

Star of the Sea Church – White Rock, British Columbia

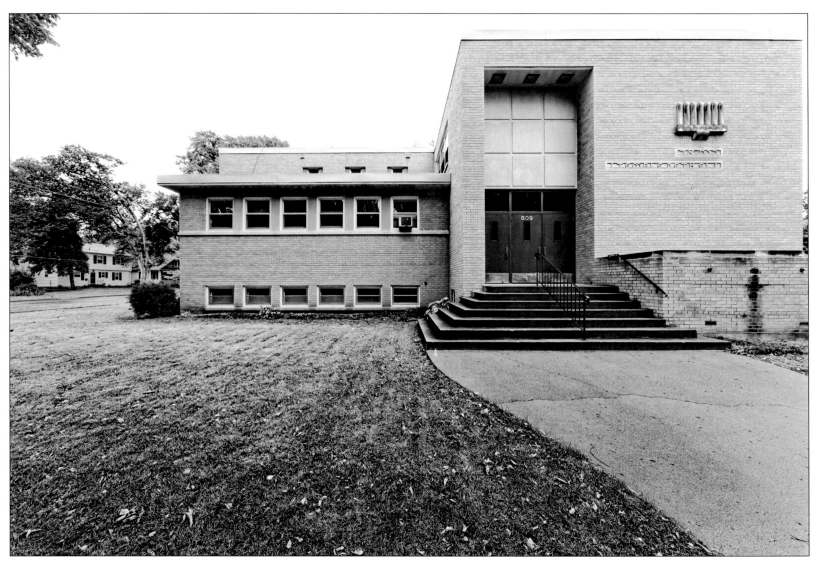

Temple Beth El – Fargo, North Dakota

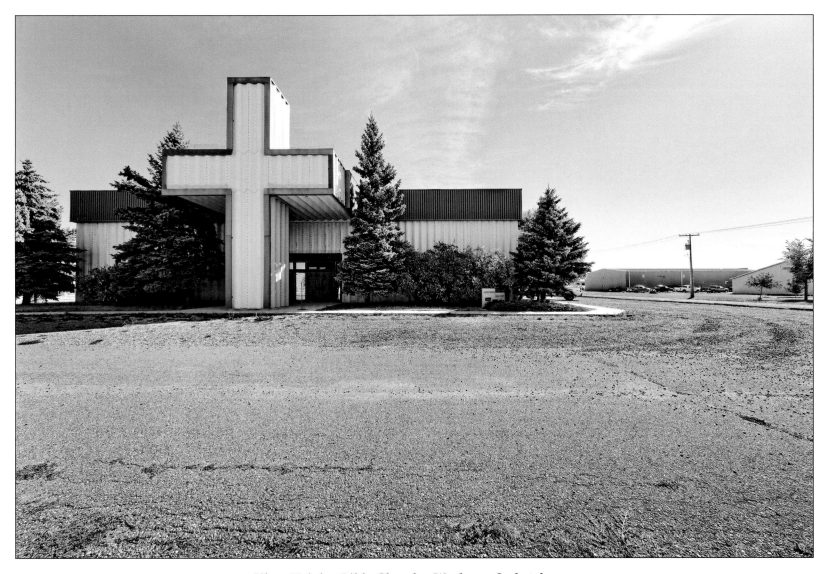

Silver Heights Bible Church – Weyburn, Saskatchewan

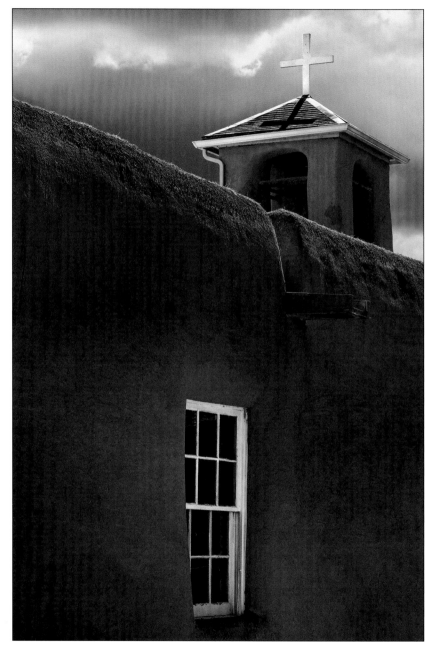

San Francisco de Asis Mission Church – Ranchos de Taos, New Mexico

Said to be one of the most photographed and painted churches in the world, this adobe structure, completed in 1816, has been the subject of paintings by Georgia O'Keeffe and photographs by two pioneers of American photography, Ansel Adams and Paul Strand. It is an excellent example of the New Mexican Spanish Colonial church.

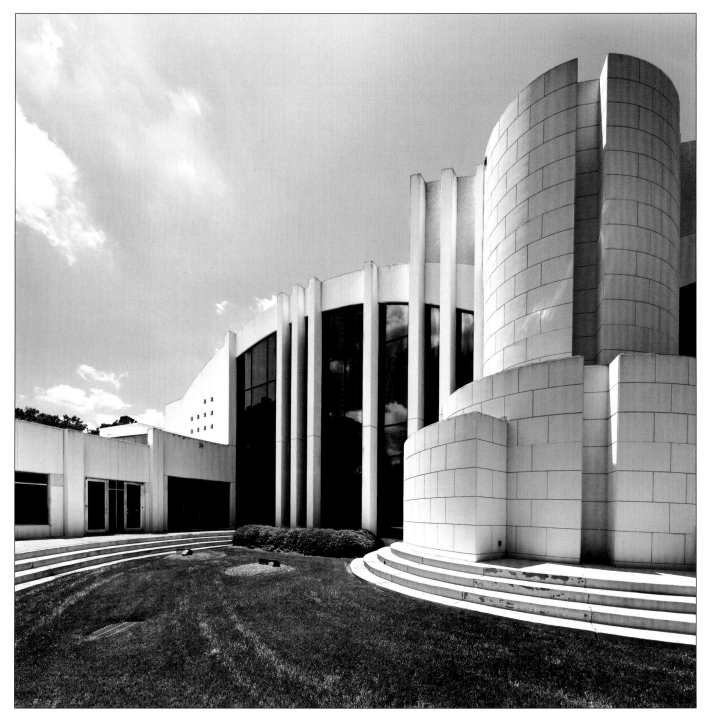

Temple Israel – Charlotte, North Carolina

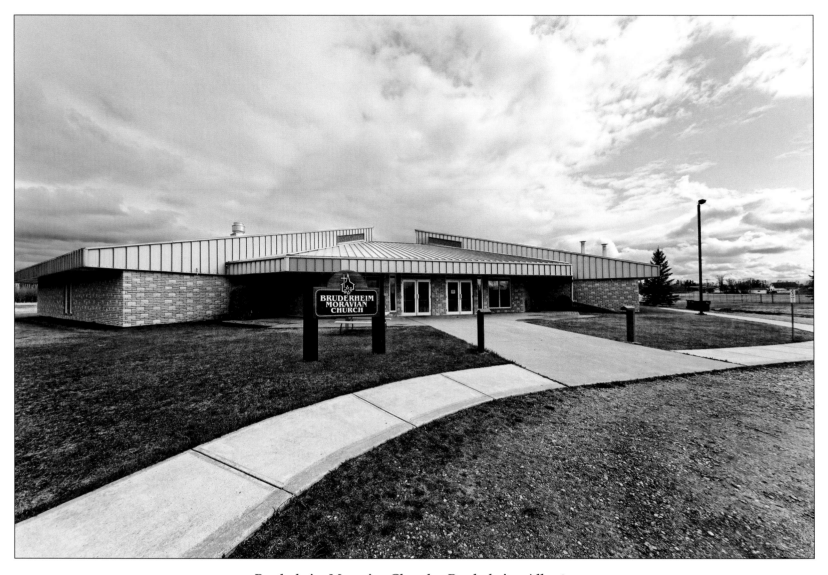

Bruderheim Moravian Church – Bruderheim, Alberta

The Moravian Church originated in the ninth century in ancient Bohemia and Moravia in what is now the Czech Republic. The congregation in Bruderheim was established in 1895 by a small group of immigrants from Ukraine.

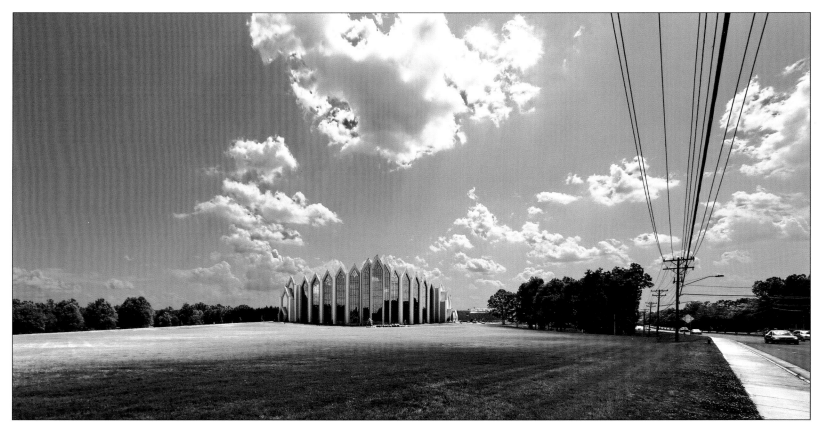

Calvary Church – Charlotte, North Carolina

The sanctuary of this 310,000-square-foot church, completed in 1989, seats more than five thousand people. Its pipe organ, with 11,499 pipes, is one of the largest in the world. The building was constructed by Ronald Roe Messner, noted builder of "megachurches," who married the evangelist television celebrity Tammy Faye Bakker in 1993. The Calvary congregation was founded in 1939 by, among others, the father of the evangelist Billy Graham.

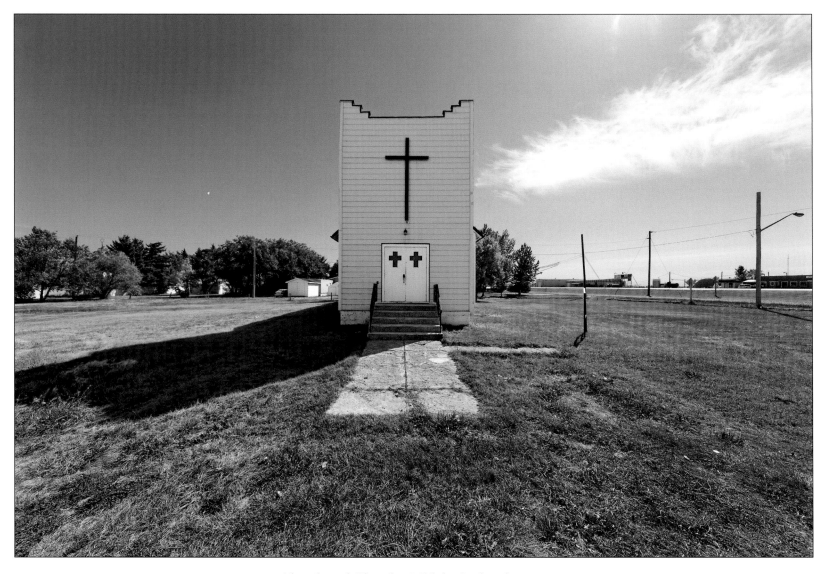

Abandoned Church – Midale, Saskatchewan

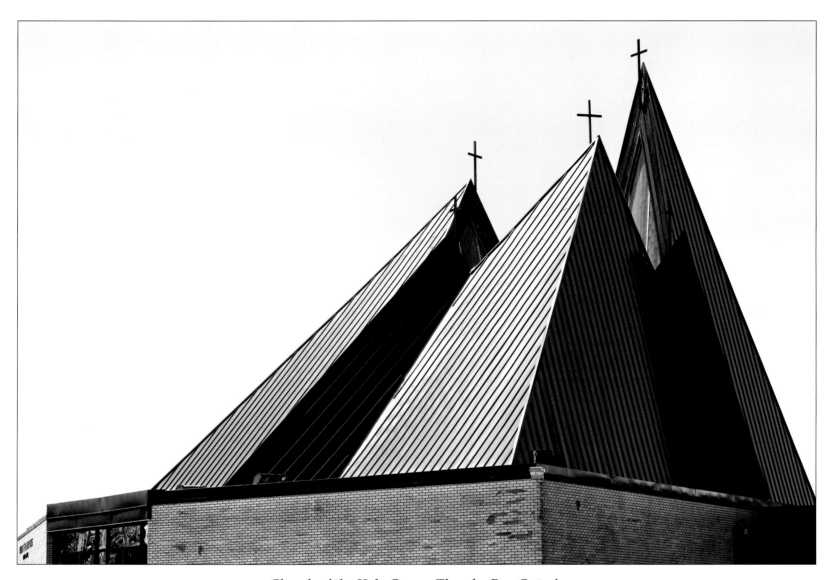

Church of the Holy Cross – Thunder Bay, Ontario

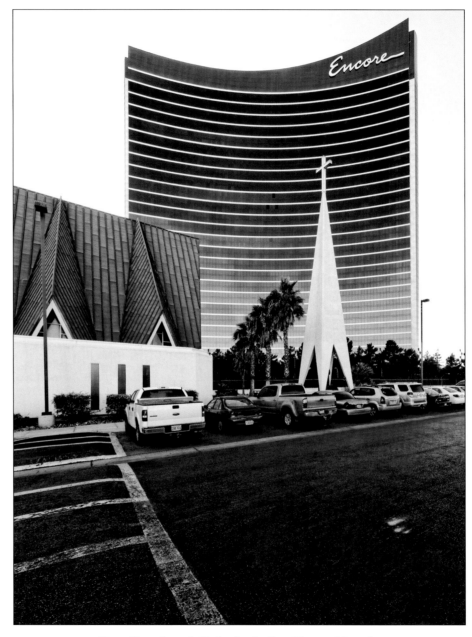

Guardian Angel Cathedral – Las Vegas, Nevada

Located on Las Vegas's glittering "Strip," the Cathedral is overshadowed by the casinos and hotels for which the city is famous. In 1961, Morris "Moe" Dalitz, a bootlegger, racketeer, and early investor in the Las Vegas gaming industry, donated the land and funds required to build the Cathedral. While this act of philanthropy was in part a deliberate attempt to improve his public image, Dalitz also had an immediate practical reason for endowing the Cathedral: the idea of a Catholic church conveniently situated for his casino workers was appealing to him.

Acknowledgments

ONCE AGAIN I MUST thank Fifth House for publishing my work. *Houses of Worship* is the third of my projects they have brought to print, and I feel fortunate to have this relationship with them.

A group of private donors responded generously to my request for financial support to help cover some of the travel costs associated with this book. I am most grateful to them and would like to acknowledge their assistance. In alphabetical order, they are:

Gail Beck

David Bennett

Wendy Bryans

Mordecai Bubis

Brian Foody

Siobhan Gallagher

Anne Giardini

Carolina Giliberti

Brian Graham

Lynn and John Graham

Gary Kaplan

Paul Kariouk

Colin Meredith

Wendy Myers

Art Olivas

Wendy Parlow

Jill Schacter

Susan Schacter

Jack Shapiro

Bill Staubi

Nina Stipich

I thank representatives of houses of worship who granted permission to publish photographs of the interiors of the buildings. They are:

Catherine Allen (Christ Church Cathedral, Victoria, British Columbia)

Father Abbot John Braganza (Abbey Church, Westminster Abbey, Mission, British Columbia)

Rick Burris (Fred W. Symmes "Pretty Place" Chapel, near Cleveland, South Carolina)

Sister Louise Charbonneau (Chapel, Mother House of the Sisters of Charity of Ottawa, Ottawa, Ontario)

Archbishop Martin William Currie (Basilica of St. John the Baptist, St. John's,

Newfoundland)

Bishop John Thomas Folda (St. Mary's Cathedral, Fargo, North Dakota)

Lynn Forbes Gautier (Cathedral of the Immaculate Conception, St. John, New Brunswick)

Peter Shurvin (Pemberton Chapel, Victoria, British Columbia)

Archbishop James Weisgerber (St. Mary's Cathedral, Winnipeg, Manitoba)

Imaad Ali (Al Salaam Mosque, Richmond, British Columbia)

Martin Chernin (Temple Sons of Israel Synagogue, Sydney, Nova Scotia)

Anna Guttman (Shaarey Shomayim Synagogue, Thunder Bay, Ontario)

Rabbi Daniel Korobkin (Beth Avraham Yoseph of Toronto Synagogue, Thornhill, Ontario)

Rabbi Moshe New (Montreal Torah Centre – Bais Menachem Chabad Lubavich)

I thank the Correctional Service of Canada for organizing my visits to Mission Institution in Mission, British Columbia, and Fraser Valley Institution in Abbotsford, British Columbia, and for permitting publication of photographs of chapels and sweat lodges at those locations.

I thank Rabbi Daniel Korobkin, Father Michael Busch, Reverend Fred Hiltz, Prof. Suwanda H. J. Sugunasiri and Imam Habeeb Alli for taking the time to answer my questions about houses of worship and for agreeing to publication of edited transcripts of our conversations.

I thank Jessie Hislop for her advice on houses of worship in Alberta.

I thank my wife and daughters for their unconditional love and support, and my two cats for never being there when I needed them.

About the photographs

Some readers may wonder how I decided which houses of worship to photograph for the book. Several broad criteria guided my choices.

- With respect to photographs taken in Canada, I tried to cover as many parts of the country as possible. I managed to photograph houses of worship in all provinces and territories except for Nunavut and the Northwest Territories.

- Within each region of Canada, I emphasized the larger cities and towns. There were, of course, a great many places that I simply could not visit because of constraints of time and budget.

- The photographs taken in the United States were products of circumstance. I brought my camera along with me as I travelled for reasons unrelated to this project.

- I aimed to include houses of worship of all major faith groups in Canada and the United States: Christianity, Islam, Hinduism, Sikhism, Buddhism, and Judaism. I did *not* try to produce a body of work that would accurately represent the relative proportions of the faith groups in the overall population. According to the most recent Canadian census data, 88 percent of people who identify themselves as having a religious affiliation[1] are Christian, 4 percent are Muslim, 2 percent are Hindu, 2 percent are Sikh, 1 percent are Buddhist and 1 percent are Jewish. Had I adhered to these statistics, the number of non-Christian houses of worship in the book would

1. In the 2011 census, 24 percent of Canadians identified themselves as having no religion.

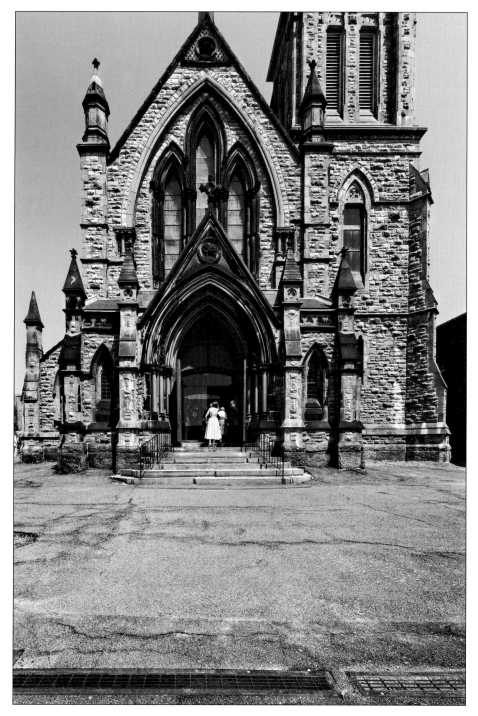

Trinity Church – St. John, New Brunswick

have been small indeed. So for the sake of interest and variety, the number of photographs of non-Christian houses of worship is disproportionate to the religious composition of the population.

- I photographed buildings in which I could find elements of visual interest. There was no plan to include certain architectural styles or time periods of construction.

Readers will note that most of the photographs are of the exterior of buildings. This was a practical matter. The interiors of most houses of worship—especially non-Christian ones—are not easily accessible to a photographer unless prior arrangements have been made. As well, permission must be obtained to publish photographs of the interiors of these private spaces. The time and effort that would have been required to gain entry to and obtain permission to publish photographs of the inside of a large number of houses of worship would have raised an insurmountable barrier to the project.

I began the photography for *Houses of Worship* in April 2012 and completed the work in August 2013. I used a Canon 1Ds Mark 3 digital camera body, with lenses ranging in focal length from 12 mm to 300 mm.

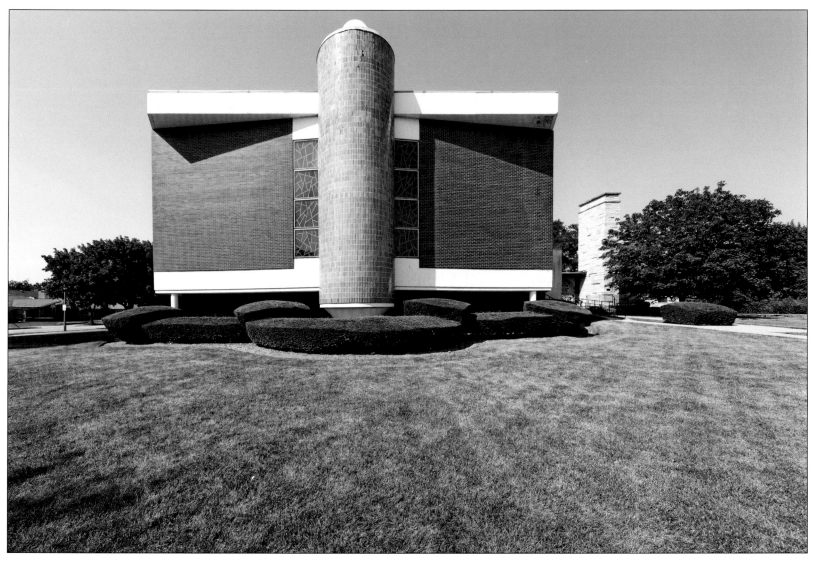

Ezra Habonim Synagogue – Skokie, Illinois

Skokie, a small city adjacent to Chicago, became a focus of international attention in the 1970s when the National Socialist Party of America, a neo-Nazi organization, announced it would hold a march there. In view of the city's large Jewish population—which included many holocaust survivors—local officials attempted to block the march, but this was overturned by the Illinois Supreme Court as a violation of free speech. Ultimately, however, the march was held in Chicago rather than Skokie.

A Note on Naming

THINGS ARE RARELY AS simple as they appear. What could be simpler, one might suppose, than knowing what to call a house of worship? All one need do is look for a sign on the building indicating the name. If still in doubt, resort to the antidote to all forms of ignorance: look it up on Google.

Indeed, in many cases this was all that was necessary. But when I was composing captions for the photographs in this book, certain niggling questions of detail arose. Many churches refer to the congregation's denomination in the name, as in *St. Thomas's Anglican Church*. Many others, such as *Holy Rosary Cathedral* (a Catholic Church) do not.

I was faced with a choice: I could either follow, word for word, the signboard in front of the church or impose my own brand of order. The former would result in captions informing readers about the denomination of some churches while remaining silent about others. I decided—for the sake of consistency—to opt for removing all references to denominations in church names. So, *St. Thomas's Anglican Church* is referred to as simply *St. Thomas's Church*. I reserved the right to ignore my own rule in cases where I felt that being a stickler would defy common sense. For example, it would be silly to abbreviate *First Baptist*

Church as *First Church*.

Some Muslim congregations incorporate into the name of their house of worship the Arabic word for mosque, which is *masjid*; others prefer the English word. For the sake of consistency I have used *mosque* in all cases.

In some cases, the name of a house of worship refers to the fact that the building serves a broader purpose, such as a cultural centre. In these cases, for the sake of simplicity and clarity, I refer to the house of worship in generic terms. So, *Gatineau Islamic Centre* is referred to as *Mosque*.

In a bilingual country such as Canada, the question of translation also arises. French names are, of course, widely used in Quebec and New Brunswick. Because this book is published in English, I have in most cases translated the French names. So Moncton, New Brunswick's *Cathédrale Notre-Dame-de-l'Assomption* is referred to as *Our Lady of the Assumption Cathedral*. But here, too, I have made exceptions. For example, because the term *Notre Dame* is relatively well integrated into English usage, at least where the naming of churches is concerned, I have not translated it to *Our Lady* for simple church names such as *Notre-Dame-de-Québec*.

List of Photographs